TREES NATIONAL CHAMPIONS

TREES NATIONAL CHAMPIONS

PHOTOGRAPHS BY Barbara Bosworth

FOREWORD BY Roger Conover

ESSAYS BY Douglas R. Nickel and John R. Stilgoe

Center for Creative Photography University of Arizona Tucson, Arizona

The MIT Press Cambridge, Massachusetts London, England

This publication is made possible in part through the generosity of Mark Schwartz and Bettina Katz and the Davey Tree Expert Company.

© 2005 Massachusetts Institute of Technology. Photographs copyright Barbara Bosworth. John R. Stilgoe essay copyright John R. Stilgoe. Douglas R. Nickel essay copyright Douglas R. Nickel.

All rights reserved. No part of this book may be reproduced in any form by any electronic or mechanical means (including photocopying, recording, or informa-tion storage and retrieval) without permission in writing from the publisher.

MIT Press books may be purchased at special quantity discounts for business or sales promotional use. For information, please e-mail special_sales@mitpress .mit.edu or write to Special Sales Department, The MIT Press, 55 Hayward Street, Cambridge, MA 02142.

This book was set in Bembo and Akzidenz Grotesk Condensed by The MIT Press, and was printed and bound in the United States of America.

Library of Congress Cataloging-in-Publication Data

Bosworth, Barbara, 1953–
 Trees : national champtions / photographs by Barbara Bosworth.
 p. cm.
 ISBN 0-262-02592-2 (alk. paper)
 1. Champion trees—United States—Pictorial works. I. Title.

SD383.3.U6B69 2005
635.9'77'0973—dc22

2005047919

10 9 8 7 6 5 4 3 2 1

For Franz Bosworth My father and champion

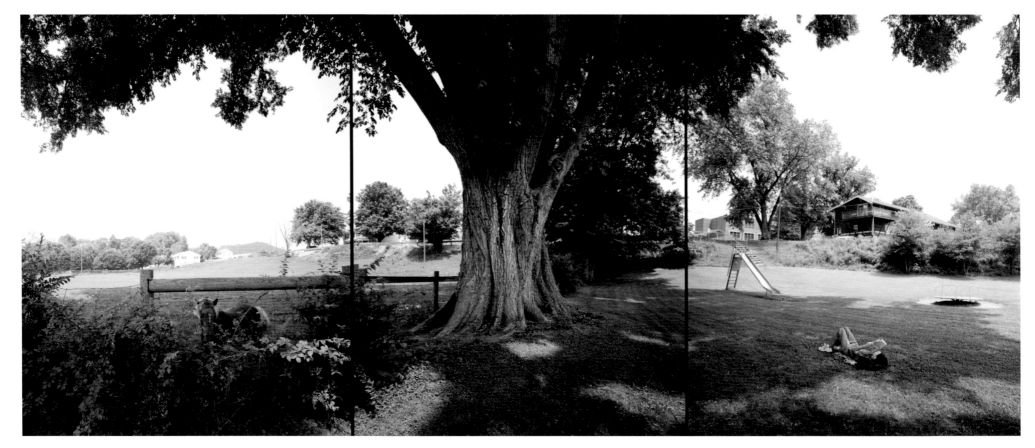

Slippery Elm with Jeffrey, Ohio, 2002

Contents

Plates

Foreword: What Is a Tree?

Roger Conover

Everyone knows what a tree is, but there is no unqualified definition. In the borderland between tree and shrub, things are less precise than among the indisputable crowns of cypress and sequoia. Philosophers, artists, and scientists have been asking why we are drawn to trees since before the time of Plato, but no writer has ever completely captured the essence of *arbor*, nor has any artist ever offered the definitive image of *treeness*. In their stillness, trees are the most elusive of beings. In their silence, trees have given voice to poets from Homer to Heaney. And in their patience, trees do not wait to be understood. They may live for thousands of years, but they die mysterious.

The towering redwood, the spreading live oak, the fall-flaming maple, the majestic elm—all are part of the mental landscape that we carry in our heads when we think of trees. But a tree can also be the inconspicuous yellow anise, the shrublike hibiscus, or the wild sumac.

A tree is commonly viewed as a woody perennial plant with a single trunk that has achieved a certain size. But when trees grow in less than optimal conditions, specimen may be found that seem to blur the distinction between trees and other plants, such as lowly shrubs. Regardless of context—whether surviving in an urban park or thriving as forest understory—a tree refuses to be anything but what it is. A tree is, and a tree always wants to remain, itself.

As an image, trees give rest to the eye. They offer themselves simply. But trees are highly organized structures whose outward figures belie the complexity of their internal systems. Connected to their major organs—roots, stems, and leaves—is a network of pumps, valves, filters, pipe lines, and processing cells that make trees, by design and function, among the most beneficial of living organisms. "The lungs of our land," Franklin Roosevelt called them, "purifying our air and giving fresh strength to our people."

What Is a Champion Tree?

In 1940, American Forests initiated the National Register of Big Trees. The purpose of this biennial registration program is to document the largest known specimen of every native or naturalized tree in the United States. By recognizing extraordinary individual trees, the program calls attention not only to the champions' size but also to the positive impact that trees have on our lives. Big trees do what other trees do in terms of environmental health, but they do it in a bigger way. At the same time, not all champion trees are giants. A tree may be the largest of its species but not the largest in the forest. The champion elliottia (plate 33), while large for its species, is unremarkable relative to the other trees around it.

Champion status is determined by measuring the circumference of the trunk in inches, the height of the tree in feet, and the spread of the canopy in feet. By this method, the tree with the highest number of total points for its species becomes the national champion, and is registered as such until surpassed by another candidate. Every year some champs are dethroned as a result of destruction or sickness, but more often newly discovered champions succeed standing ones to take the crown. Currently, there are 889 national champions and cochampions among the 826 eligible species in the United States. The state of Florida has the most, with 163, followed by California, 102; Arizona, 84; Texas, 80; Virginia, 56. The trees depicted in this book are some of those champions.

Photographs by Barbara Bosworth

1. Darlington Oak, Georgia, 1999

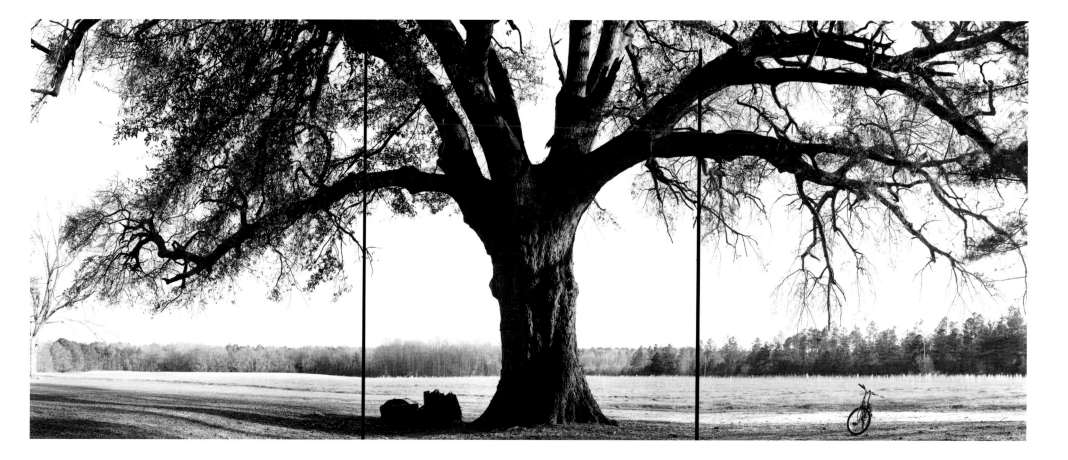

2. *Singleleaf Ash, Colorado, 2001*

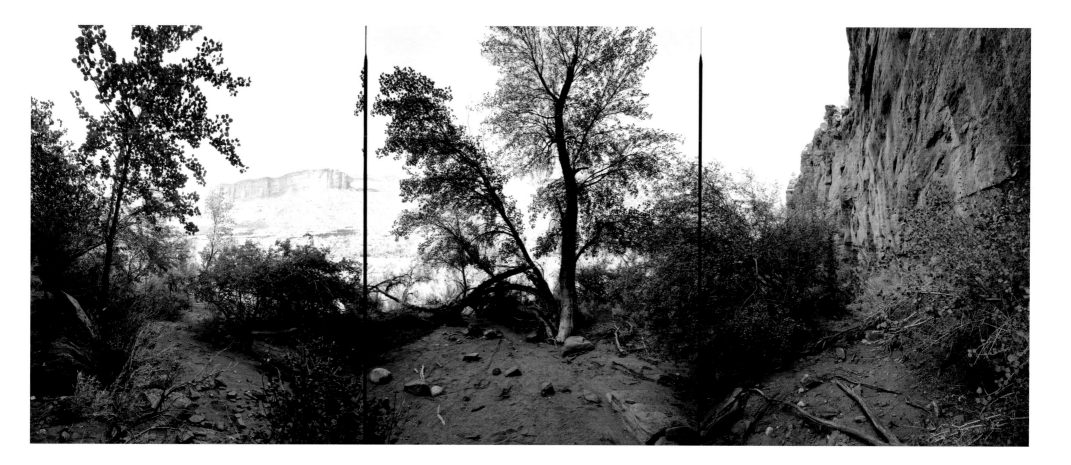

3. *Giant Sequoia, California, 1994*

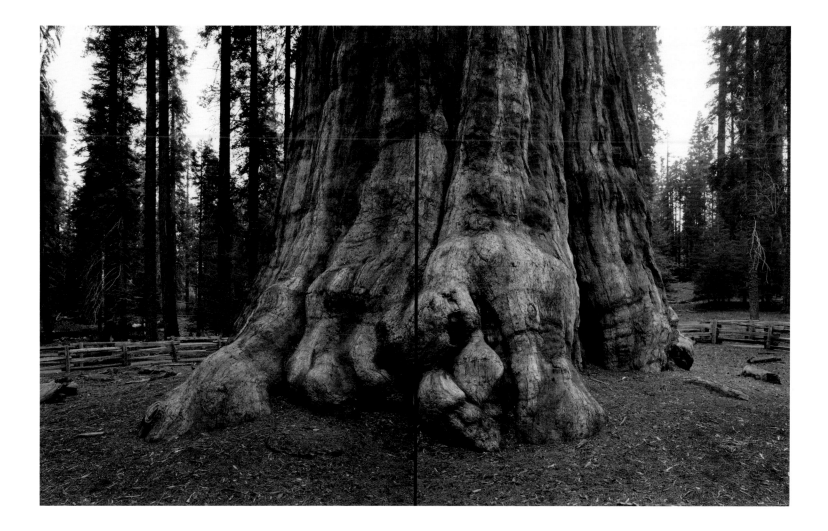

4. Bur Oak, Kentucky, 1991

5. *Longbeak Eucalyptus, Arizona, 2001*

6. *Sand Live Oak, Florida, 2002*

13

8. Western Redcedar, Washington, 1993

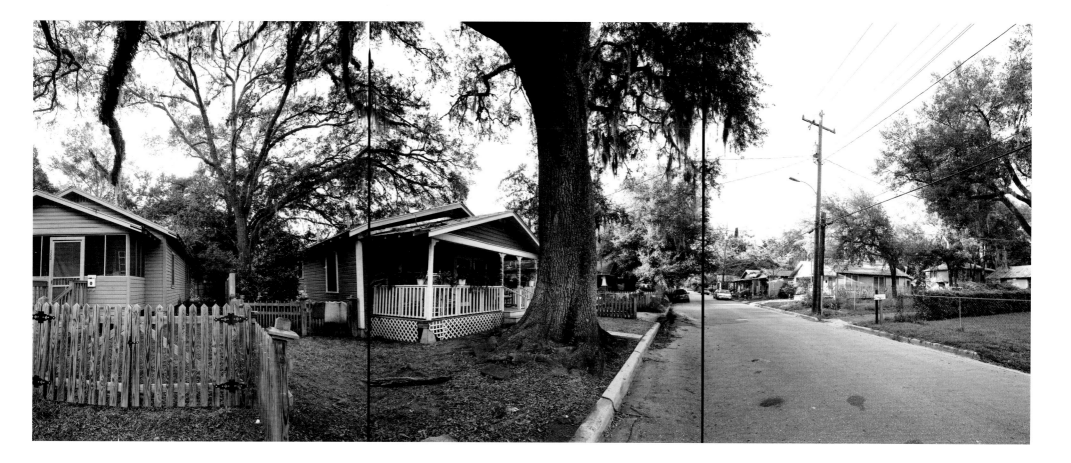

7. *Aloe Yucca, Georgia, 2002*

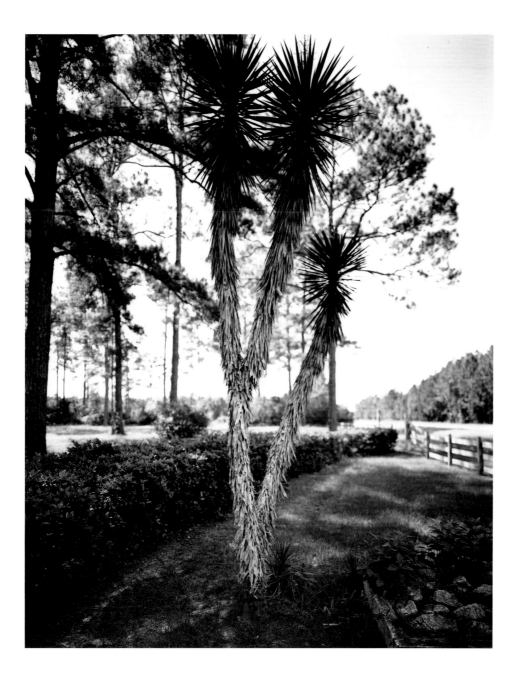

8. Western Redcedar, Washington, 1993

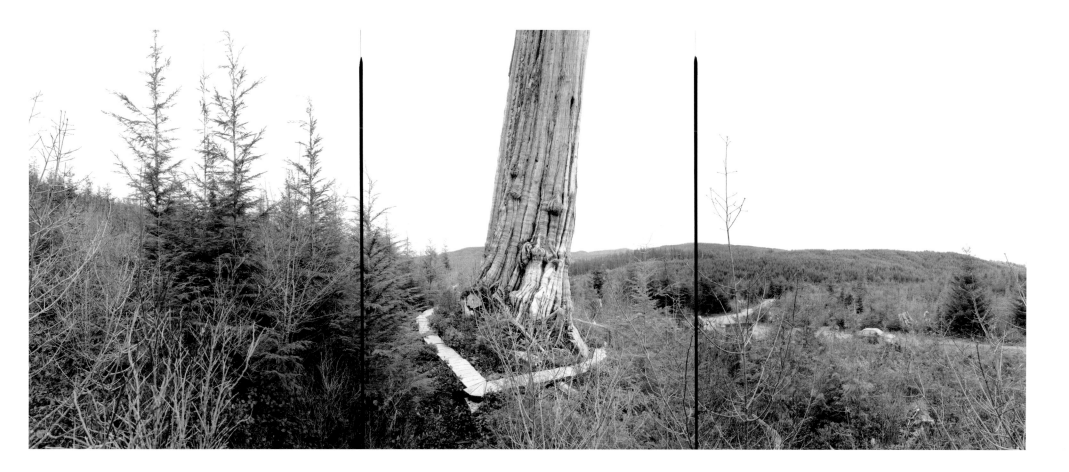

9. *Velvet Mesquite, Arizona, 2001*

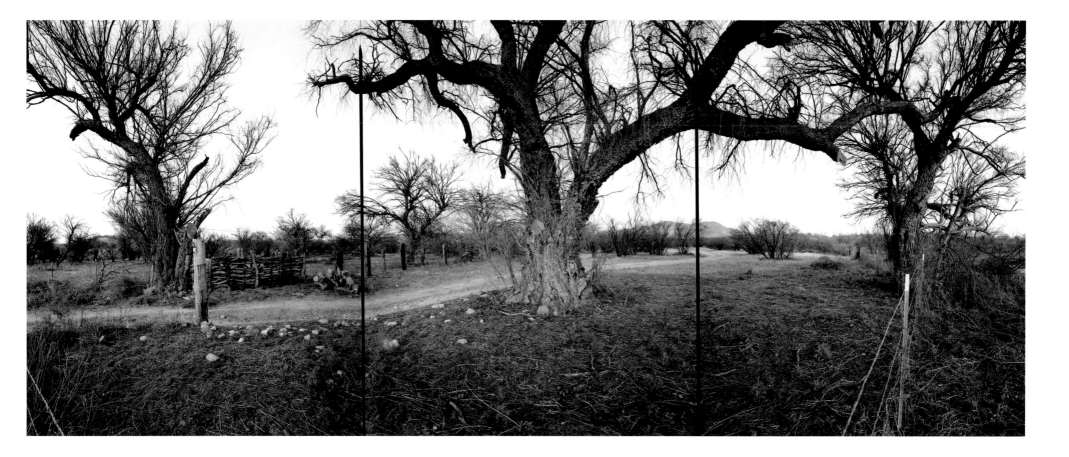

10. Saguaro, Arizona, 2001

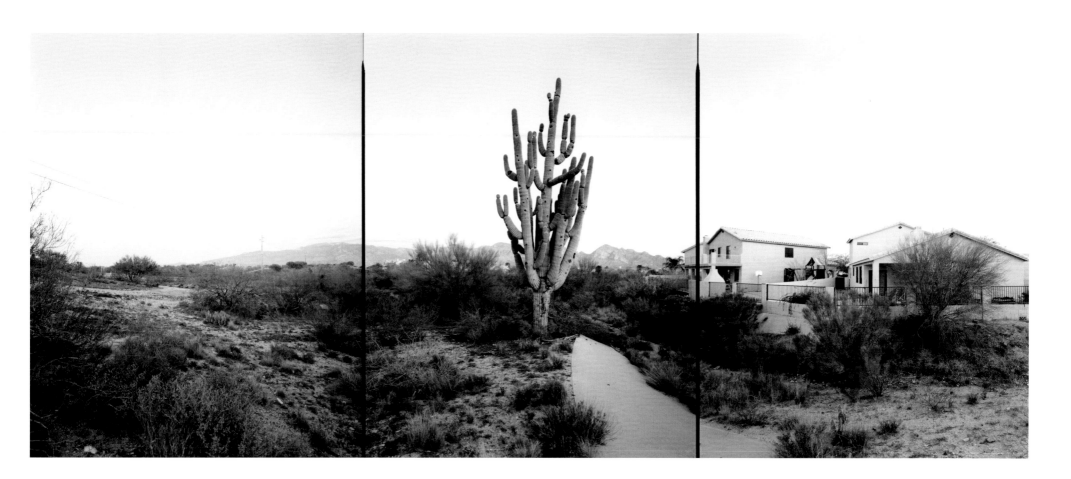

11. *Northern Red Oak, New York, 1990*

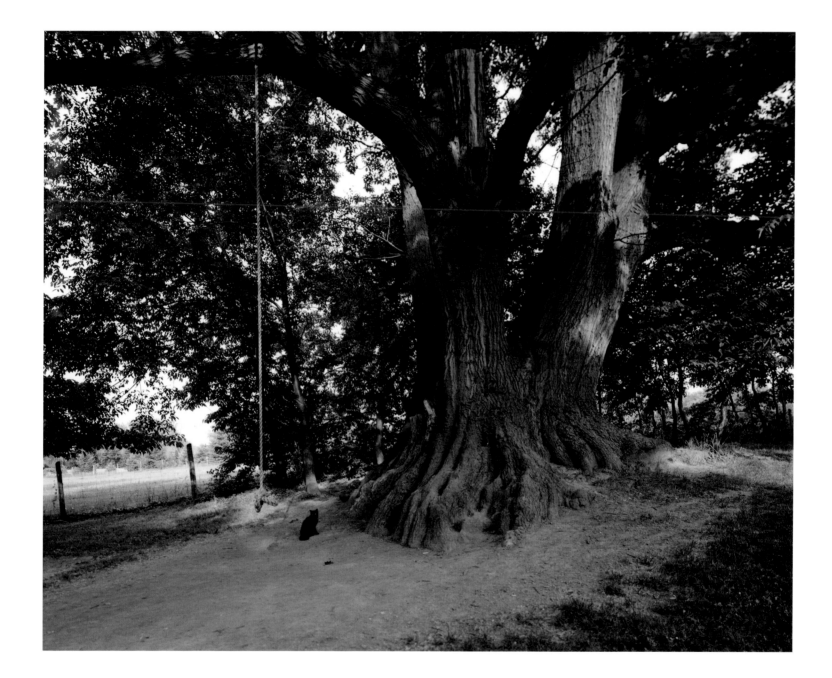

12. *Northern Red Oak, New York, 1991*

13. Siberian Elm, Colorado, 2000

14. *Blackjack Oak, Georgia, 1999*

15. American Elm, Kansas, 1990

16. Joshua-tree, California, 2002

17. *Ohio Buckeye, Ohio, 2004*

18. Green Ash, Michigan, 1992

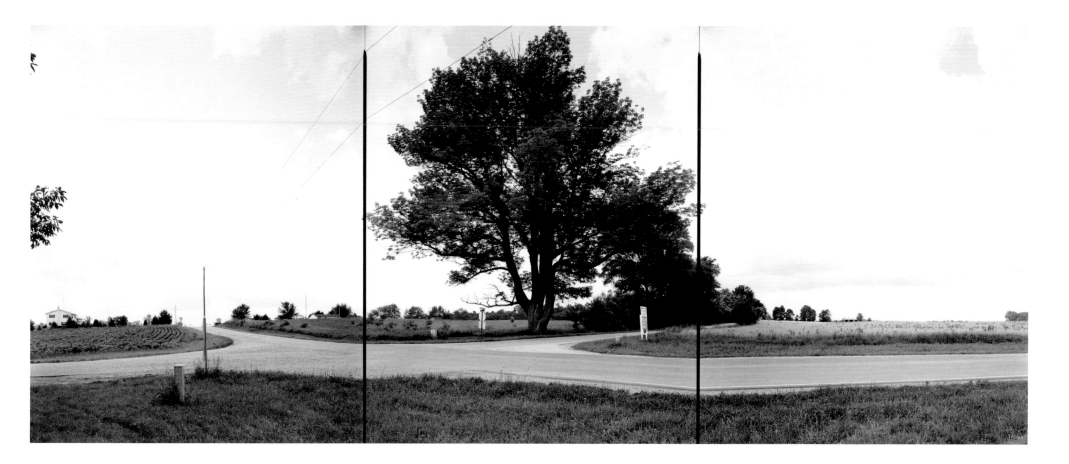

19. Waterlocust, Pennsylvania, 2000

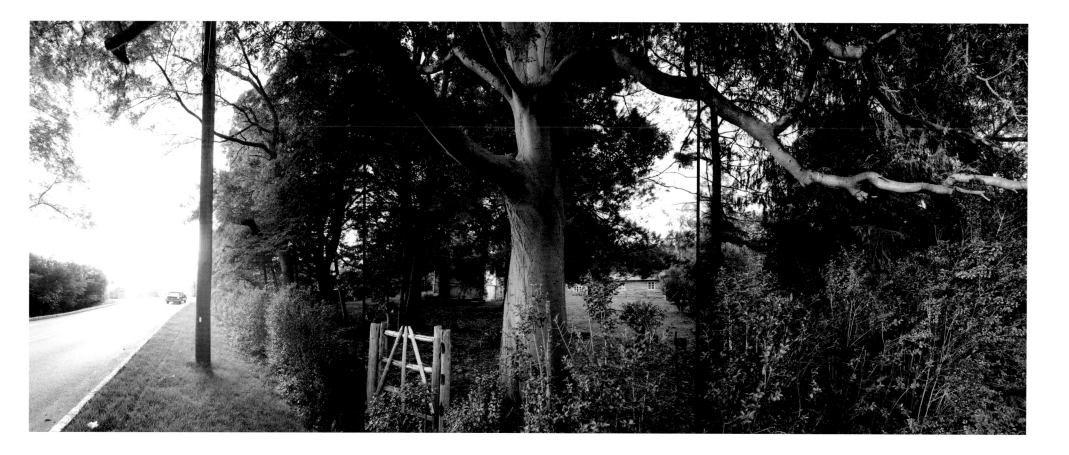

20. Coast Redwood, California, 1994

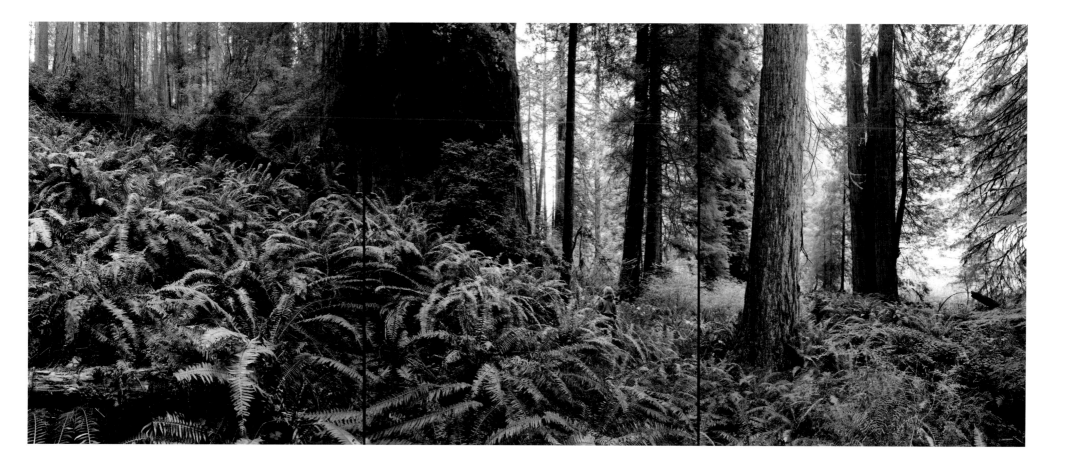

21. *Mazzard Cherry, Pennsylvania, 1994*

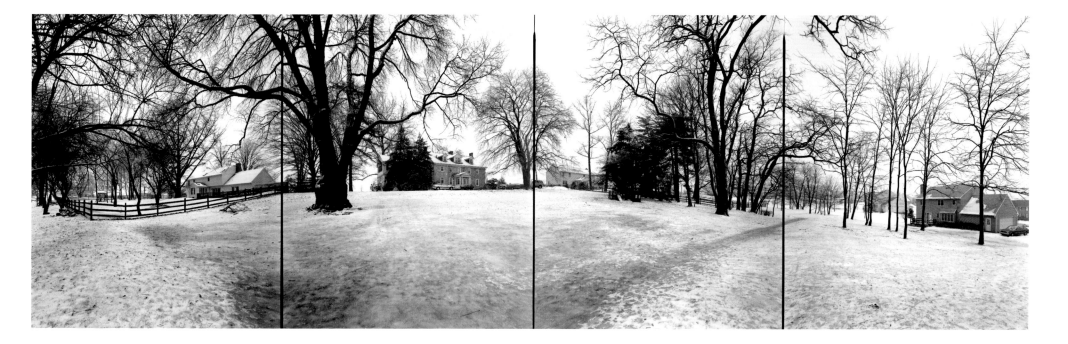

43

22. *Turkey Oak, Georgia, 1994*

23. Gumbo-limbo, Florida, 1995

24. *Valley Oak, California, 1994*

25. *White Oak, Maryland, 1992*

26. *Sycamore with Katie, Ohio, 1990*

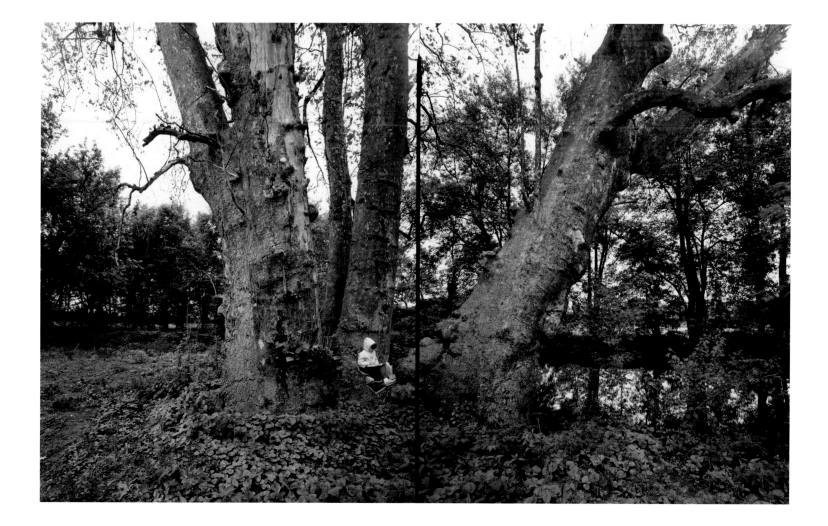

27. *Emory Oak, Arizona, 2001*

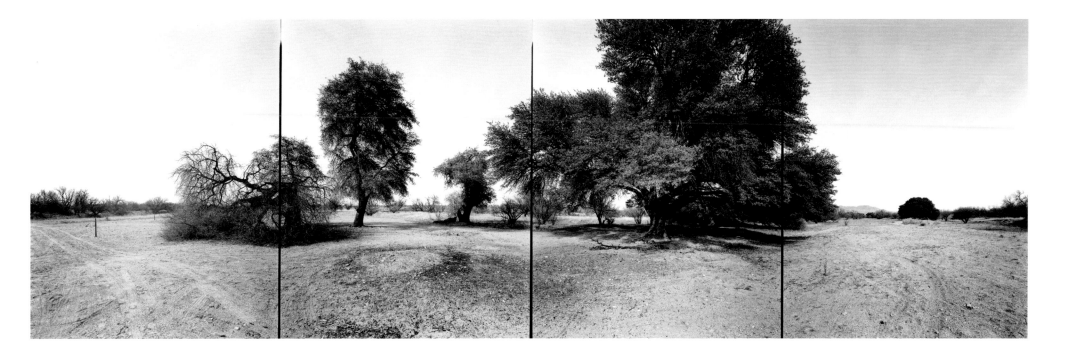

28. Osage-orange, Virginia, 2002

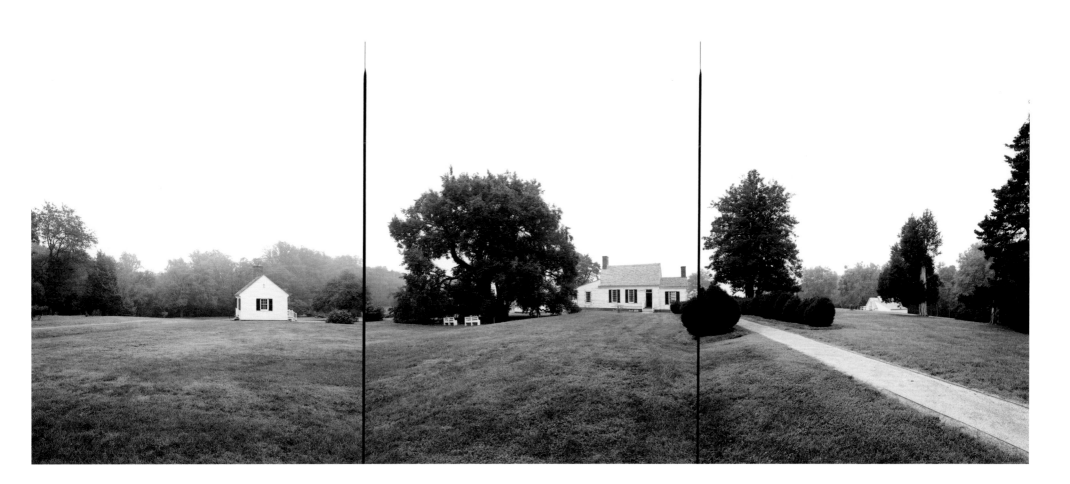

29. Weeping Willow, Michigan, 1992

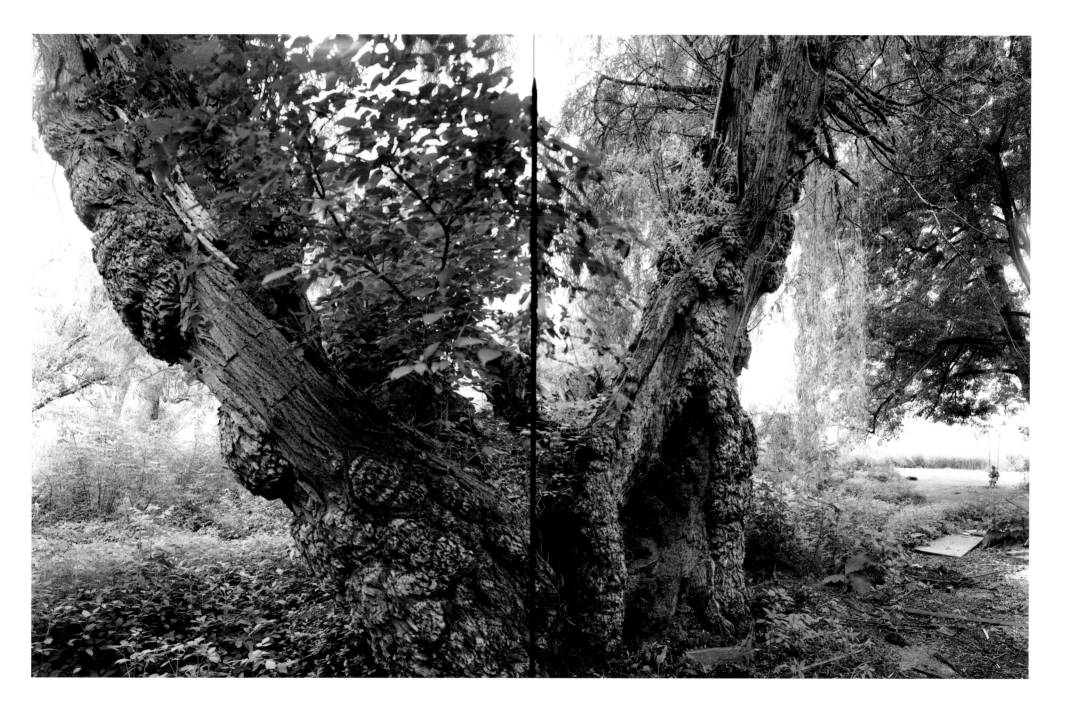

30. Plains Cottonwood, Colorado, 1991

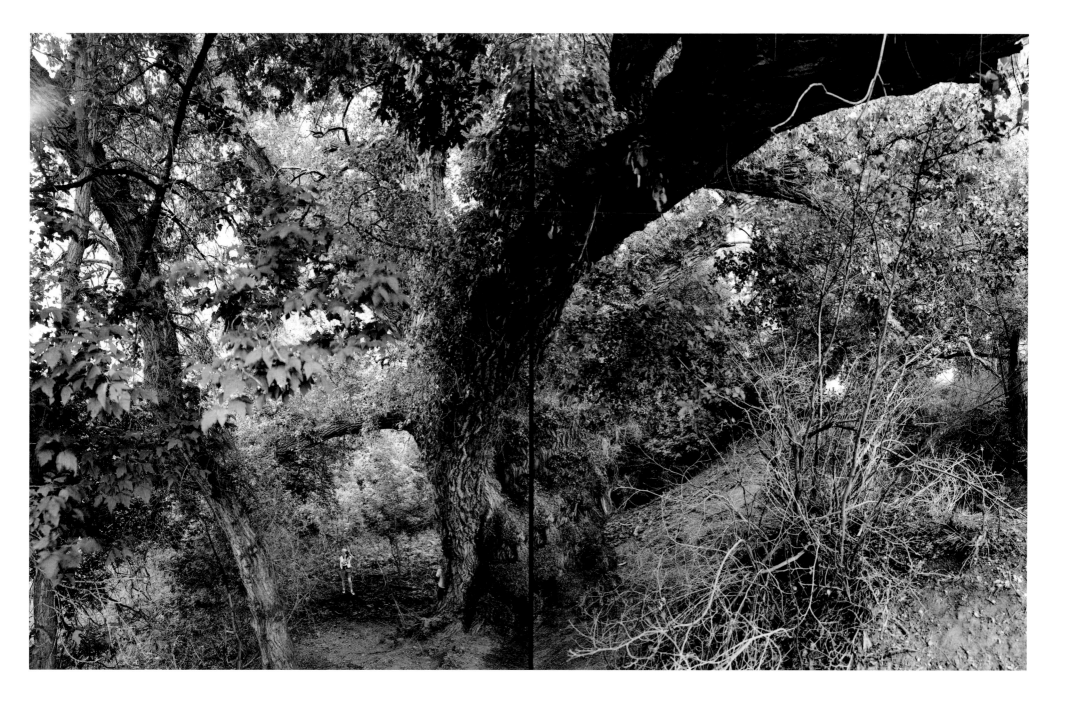

31. Black Oak, Connecticut, 2001

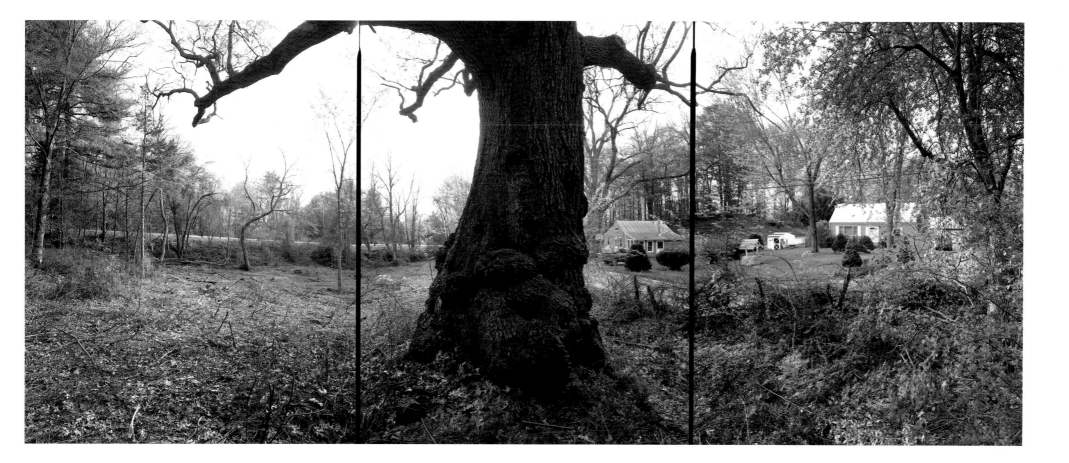

32. Chinkapin Oak, Kentucky, 2002

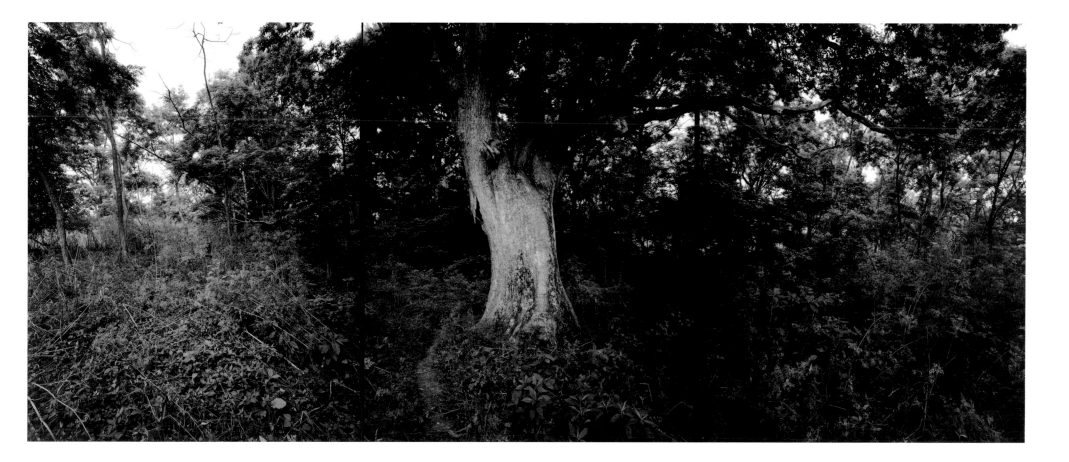

33. Elliottia, Georgia, 2002

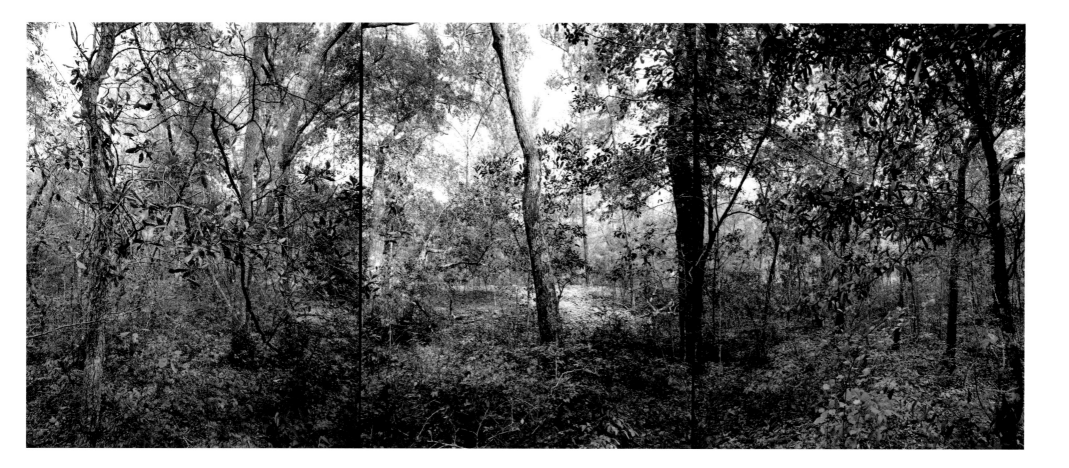

34. Pignut Hickory, Georgia, 2002

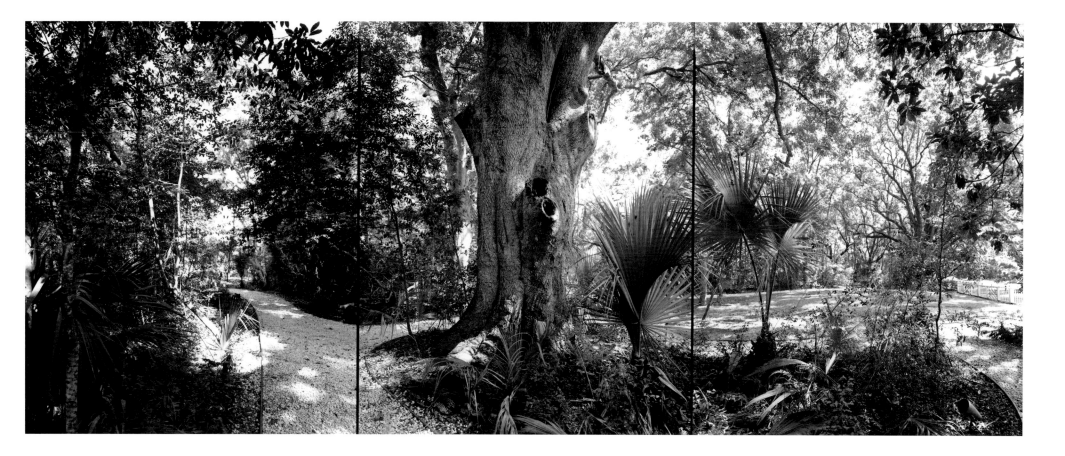

35. Two-wing Silverbell, Ohio, 2002

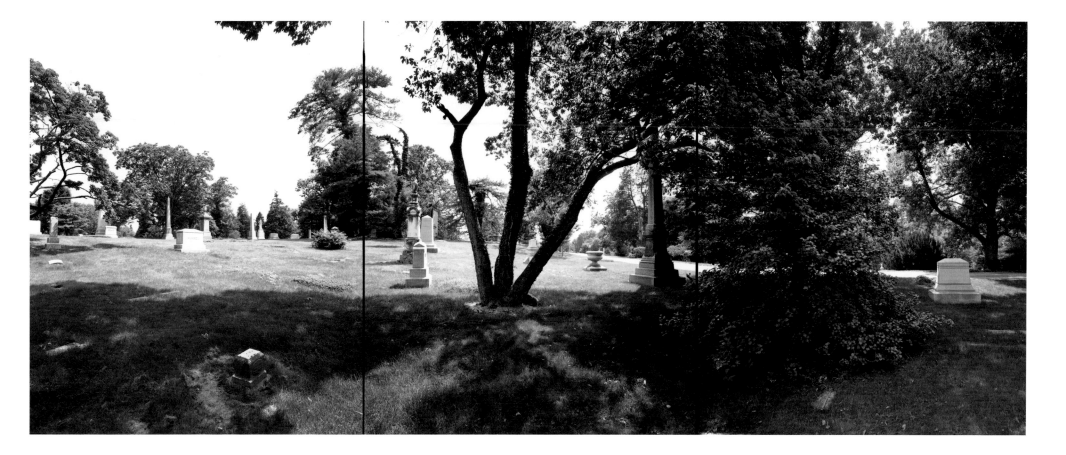

36. *Sugarberry, South Carolina, 1994*

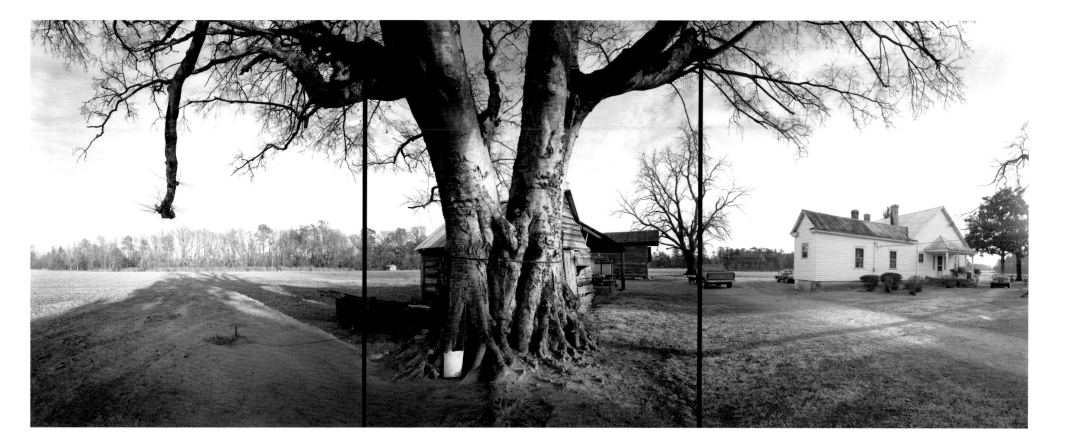

37. Sitka Spruce, Oregon, 1993

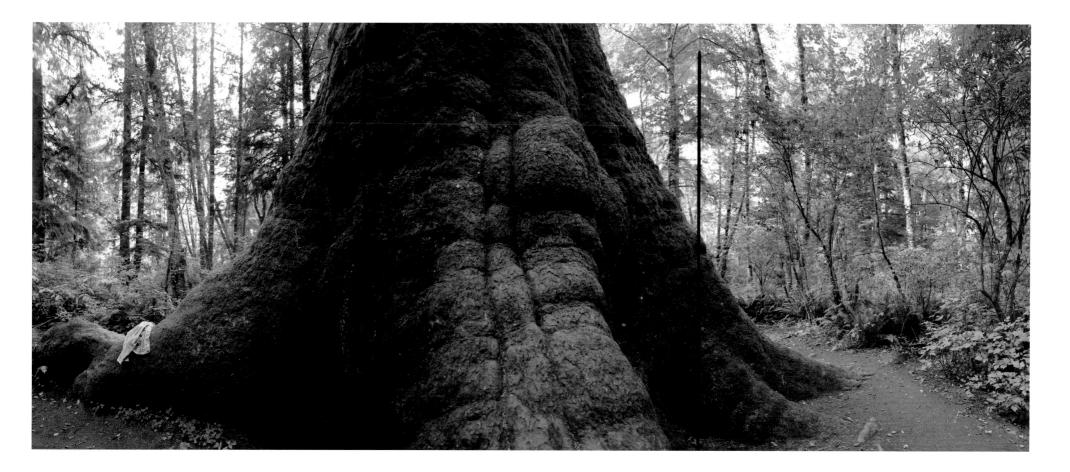

38. Common Pear, Ohio, 2002

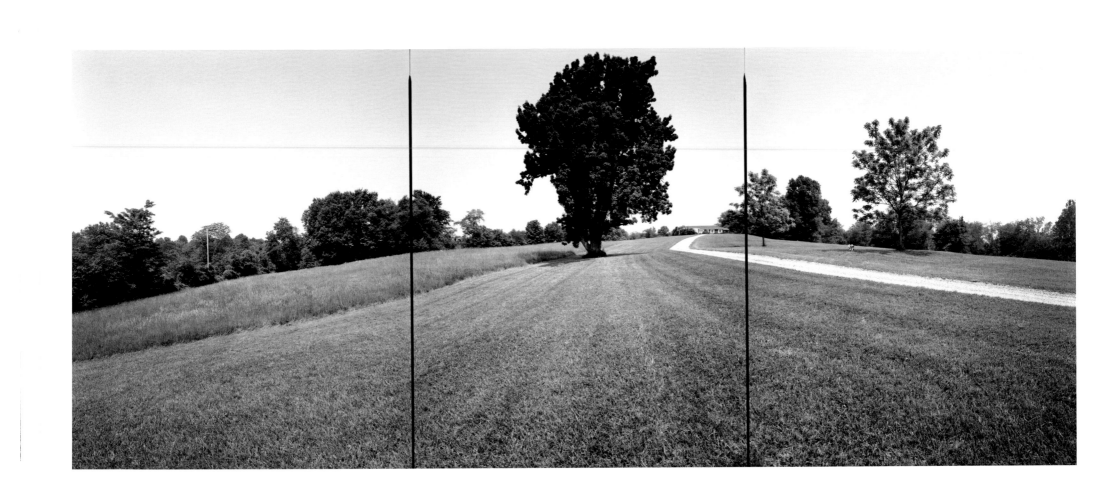

42. *Pitch Pine, New Hampshire, 2003*

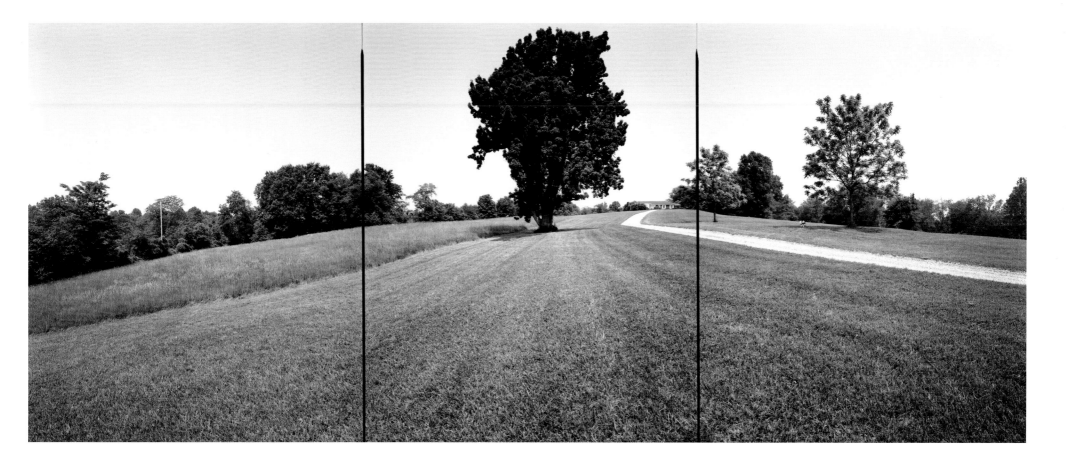

39. Royal Paulownia, Indiana, 1991

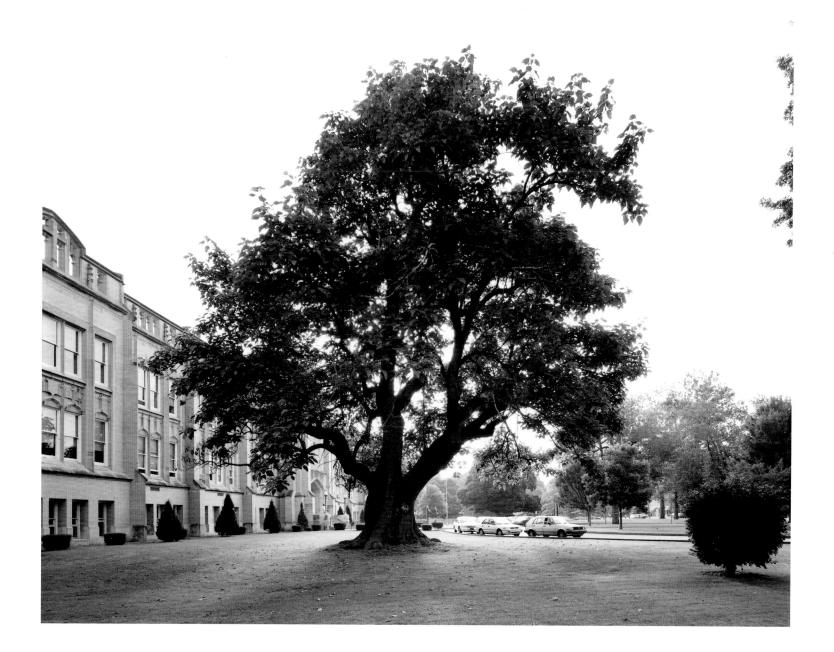

40. *Southern Red Oak, Georgia, 1999*

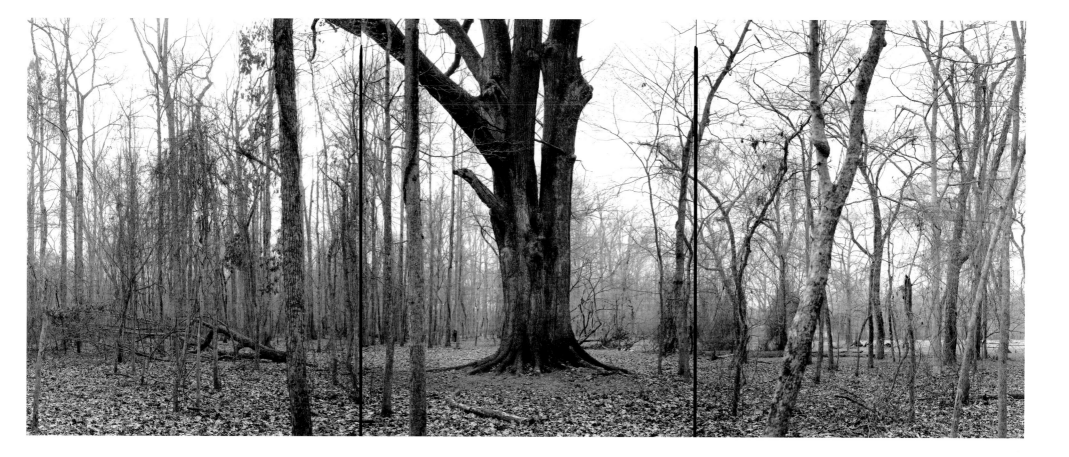

41. Siberian Elm, Ohio, 2002

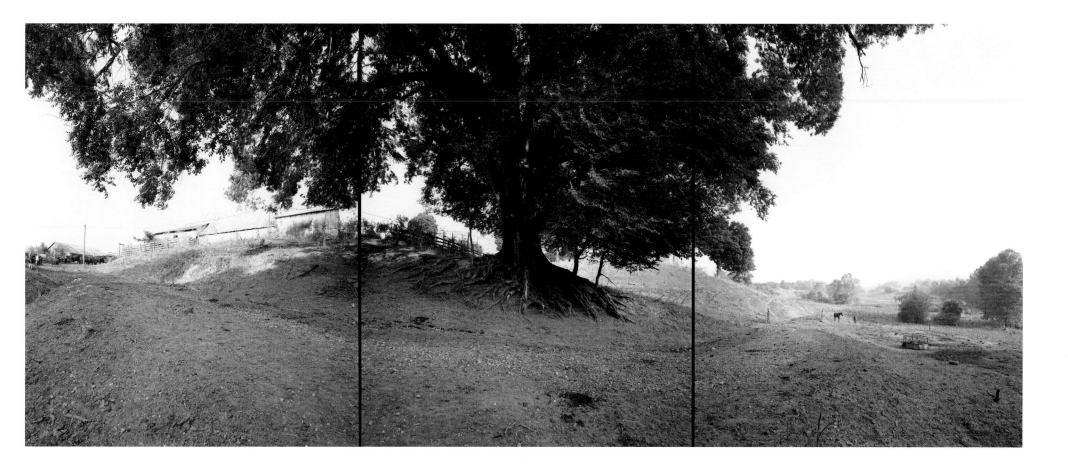

42. *Pitch Pine, New Hampshire, 2003*

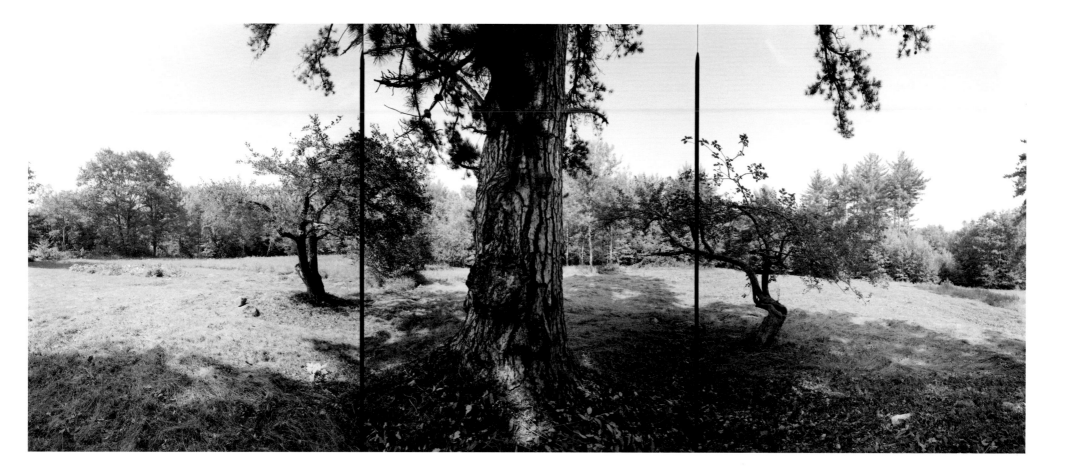

43. *Pussy Willow, Rhode Island, 1992*

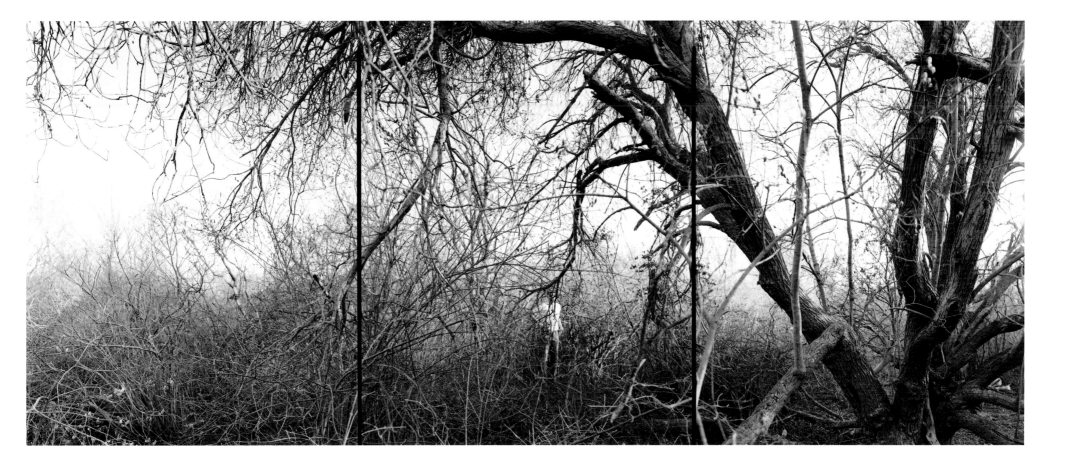

44. Monterey Cypress, California, 2002

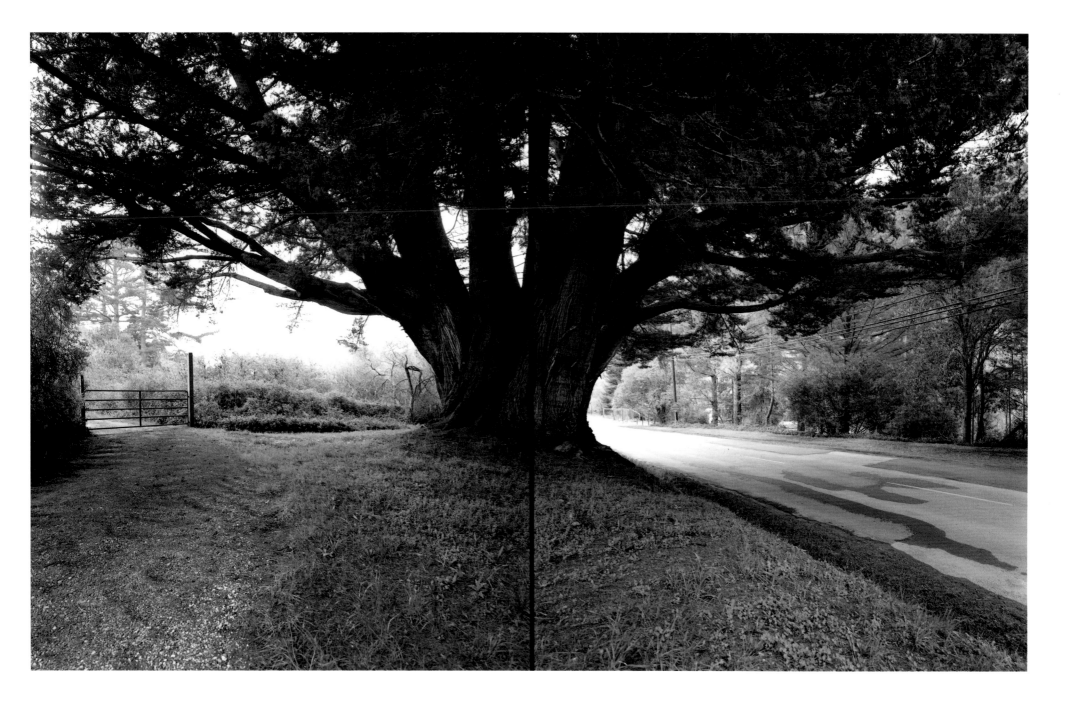

45. *Black Locust, New York, 1991*

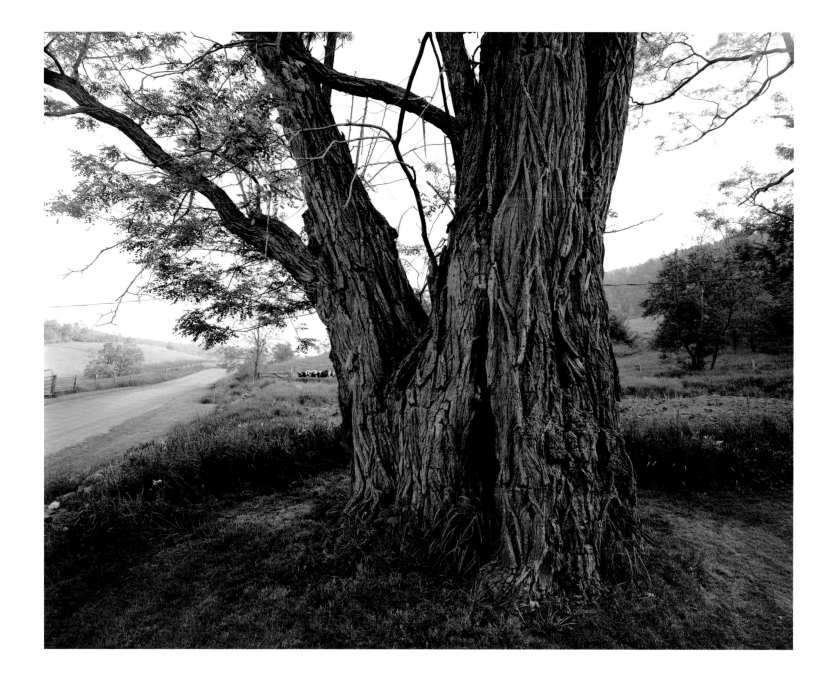

46. *Common Pear, Washington, 1994*

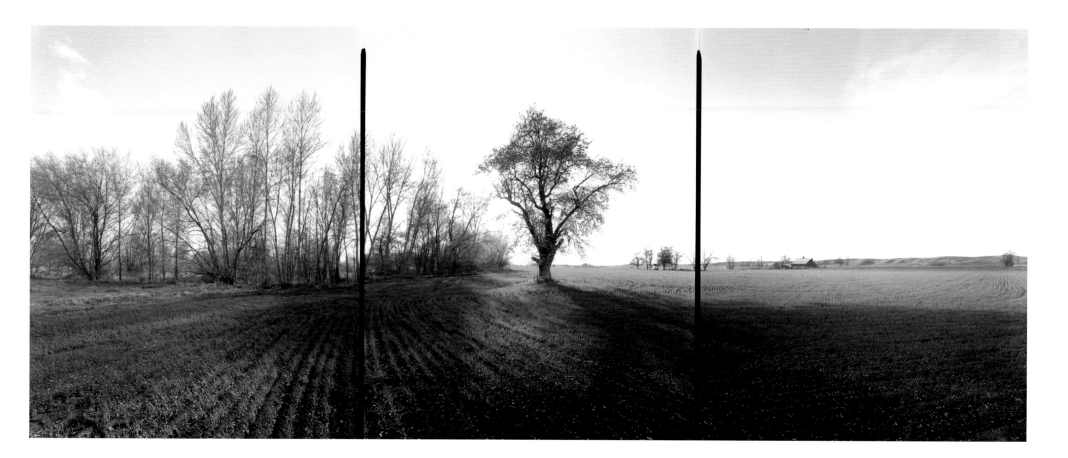

47. *Pacific Madrone, California, 1994*

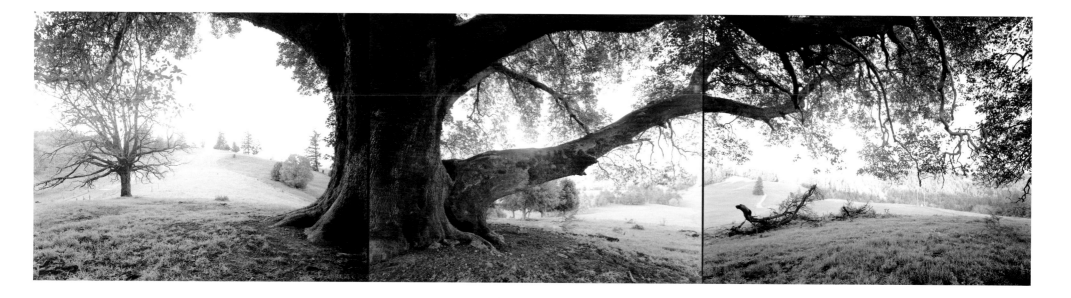

48. *Fremont Cottonwood, Arizona, 2001*

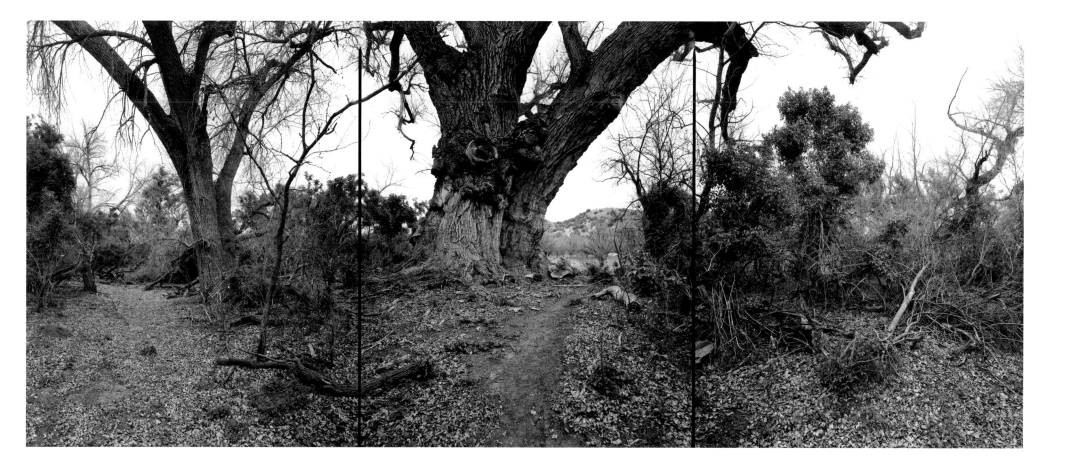

49. Southern Redcedar, Florida, 1994

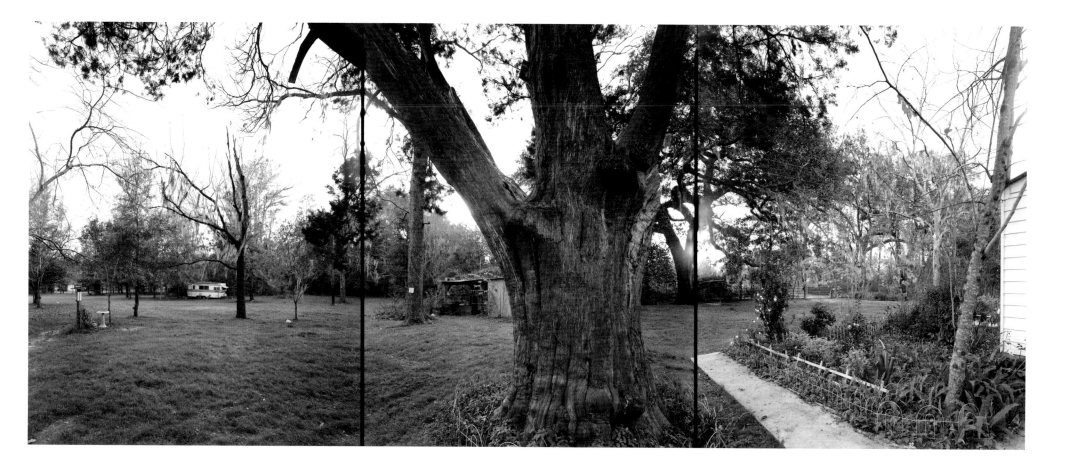

50. Mountain Paper Birch, Michigan, 1994

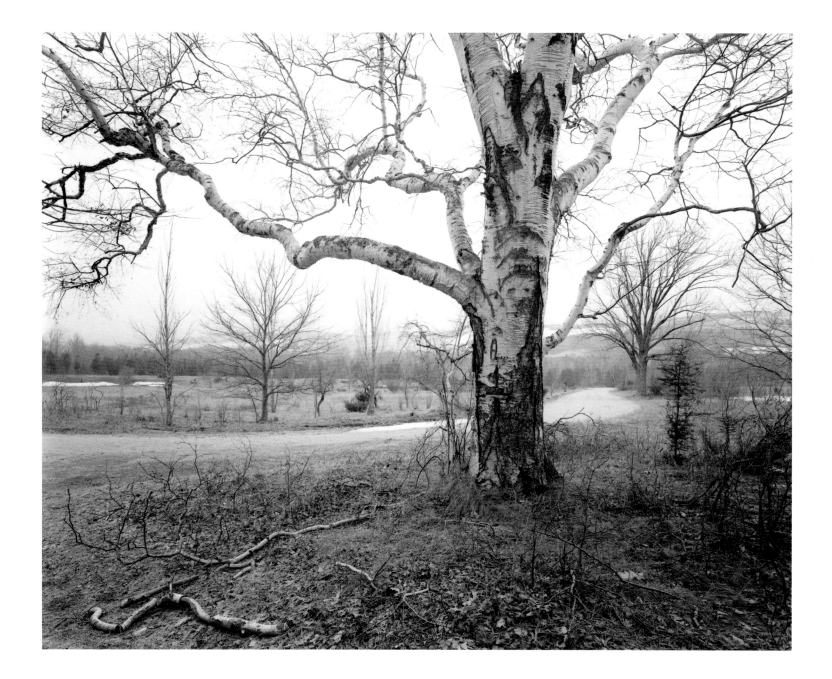

51. Slippery Elm, Ohio, 2000

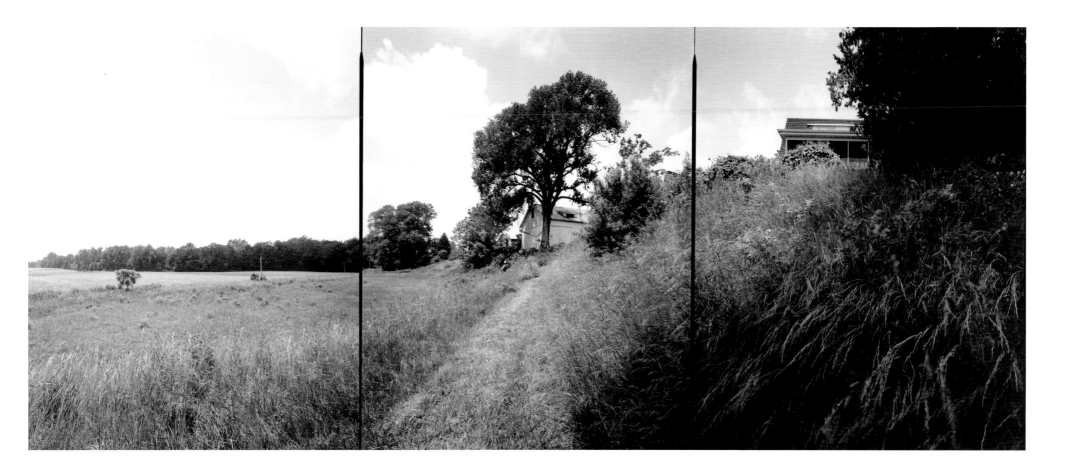

52. Common Hackberry, Illinois, 2001

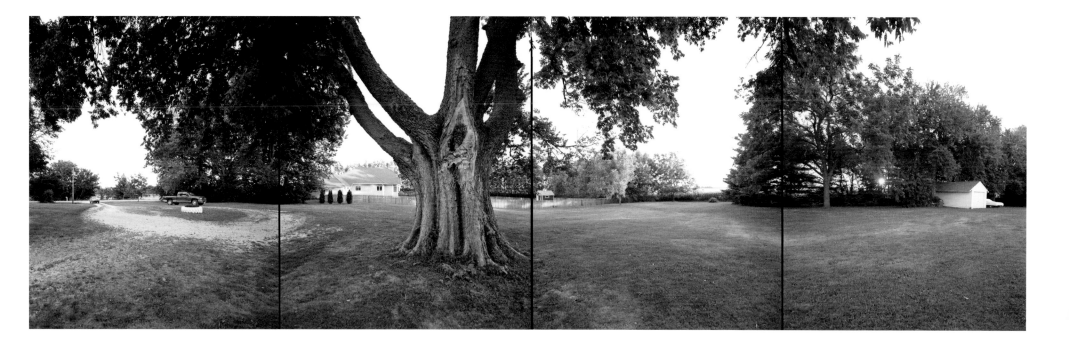

53. *Strangler Fig, Florida, 1995*

54. Tuliptree Yellow-poplar, Virginia, 1992

55. American Smoketree, Indiana, 2001

56. *American Beech, Ohio, 1990*

57. Paper Birch, Maine, 1991

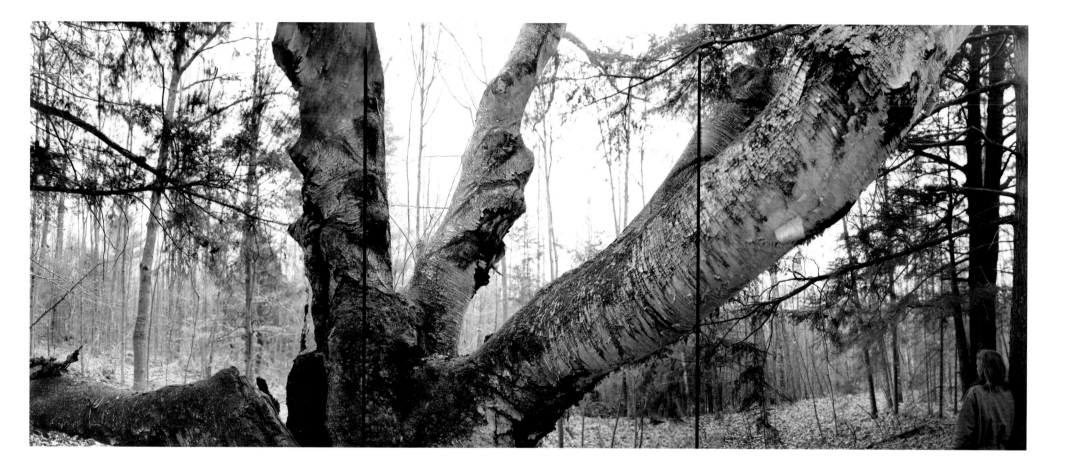

58. Red Mangrove, Florida, 1995

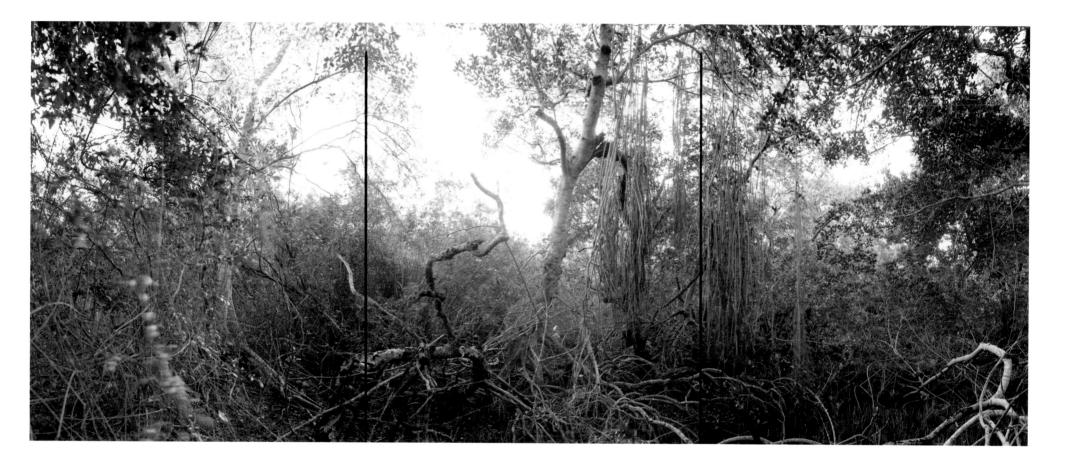

59. Sycamore, Kentucky, 2002

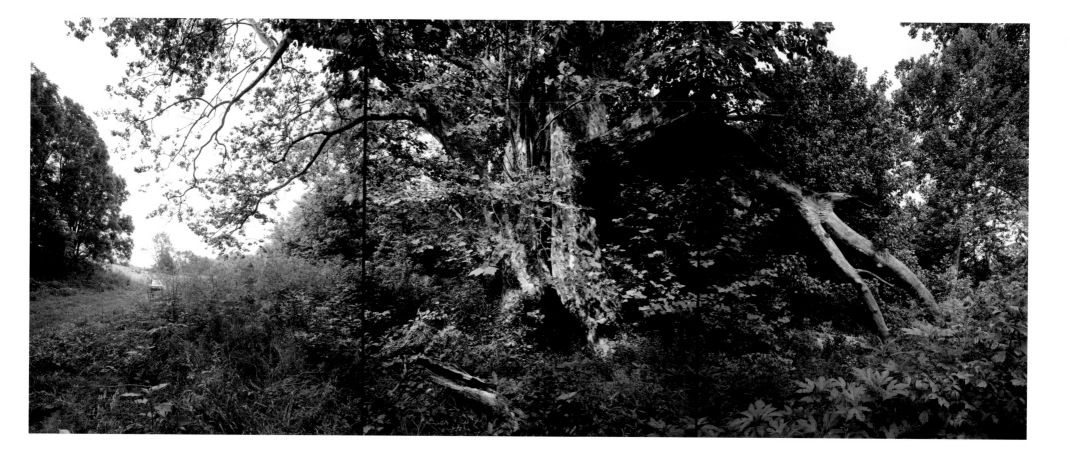

60. *Western Paper Birch, Washington, 1993*

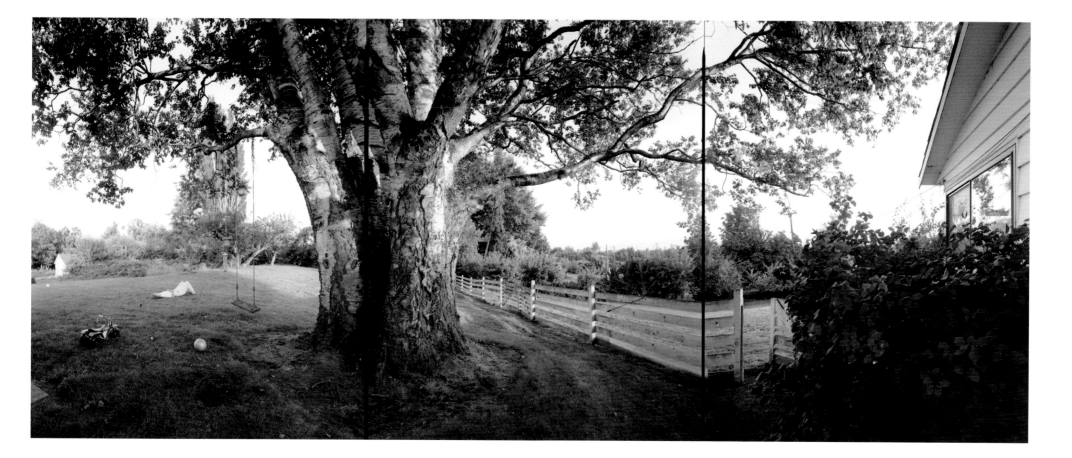

61. Butternut, Oregon, 1993

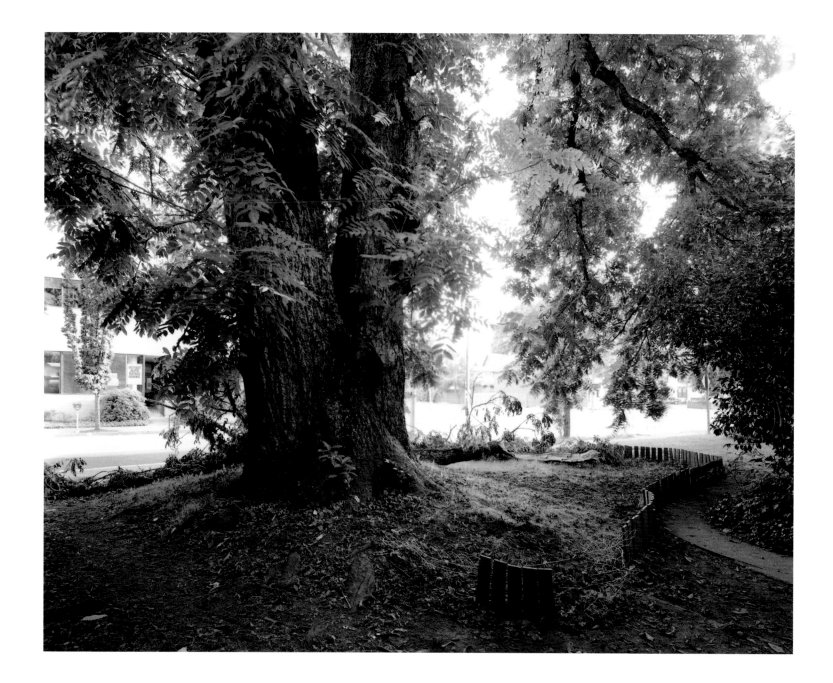

62. Scarlet Oak, Michigan, 1992

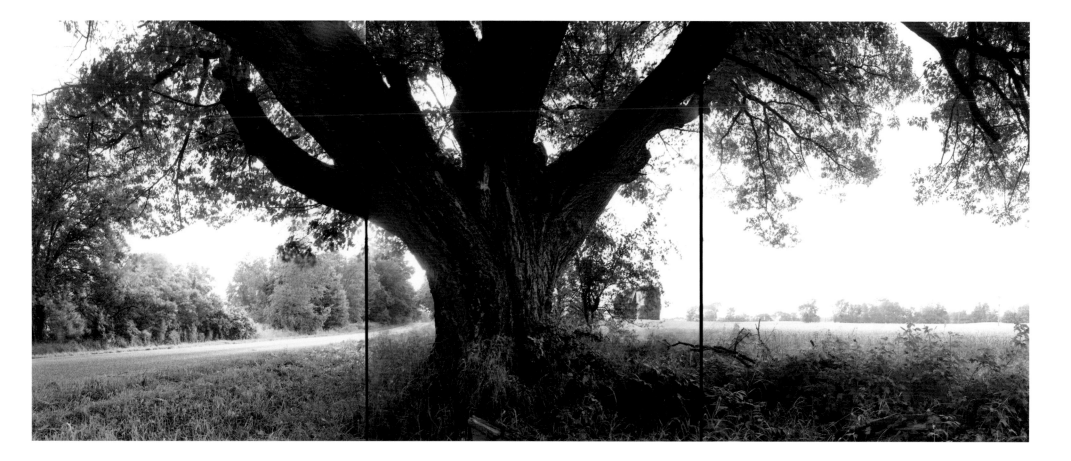

63. *Golden (White) Willow, Michigan, 1992*

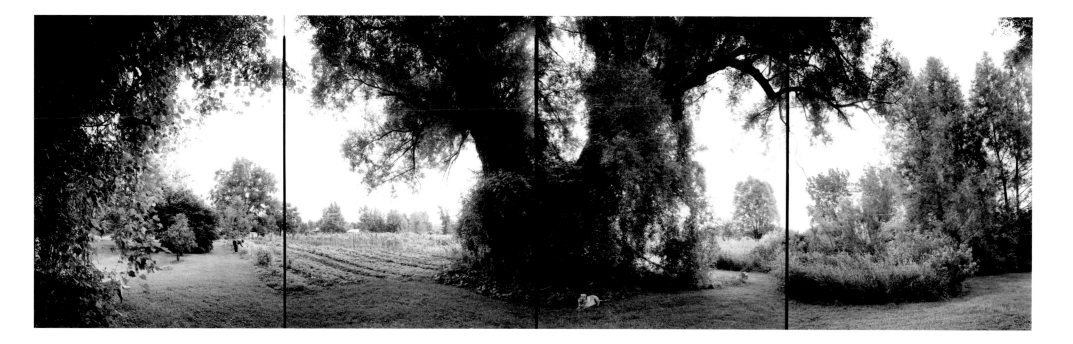

64. *Durand Oak, Georgia, 1999*

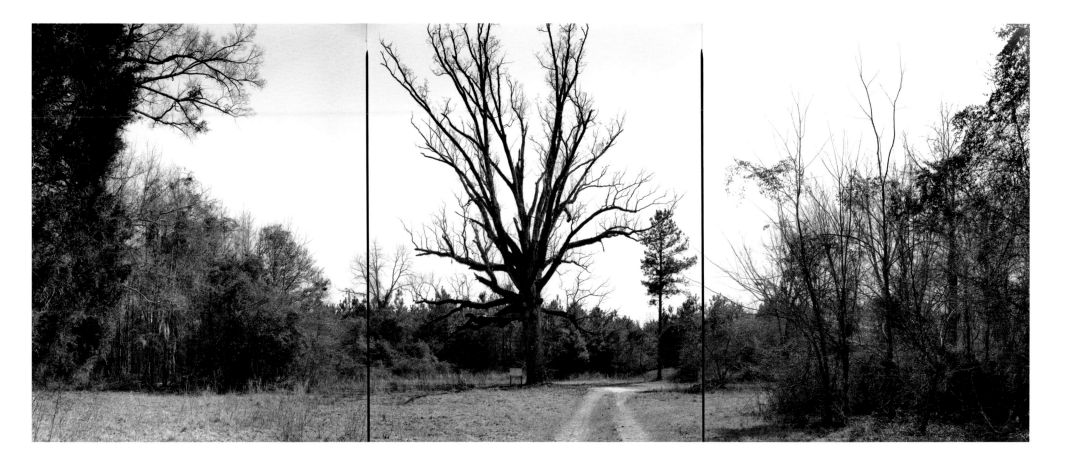

65. *California Buckeye, California, 2002*

66. *Swamp White Oak, Ohio, 2002*

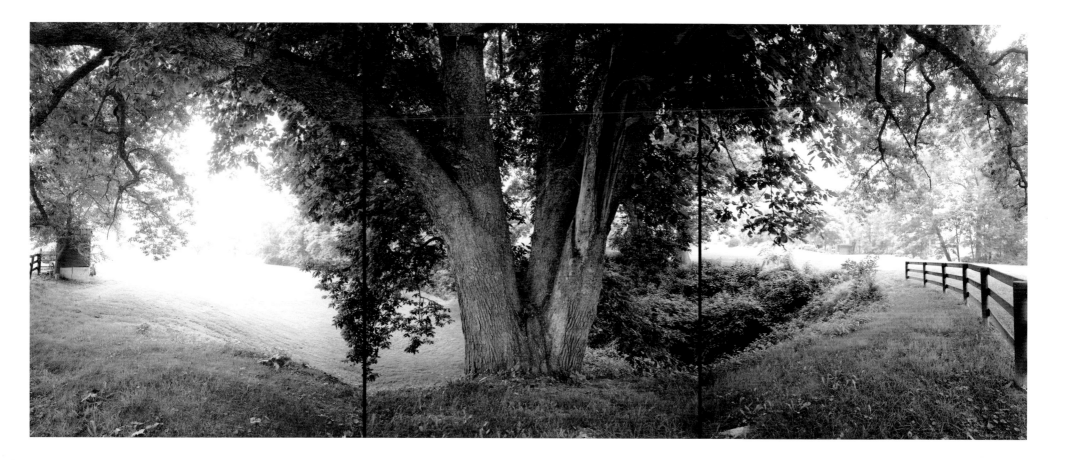

67. Scarlet Oak, Kentucky, 2002

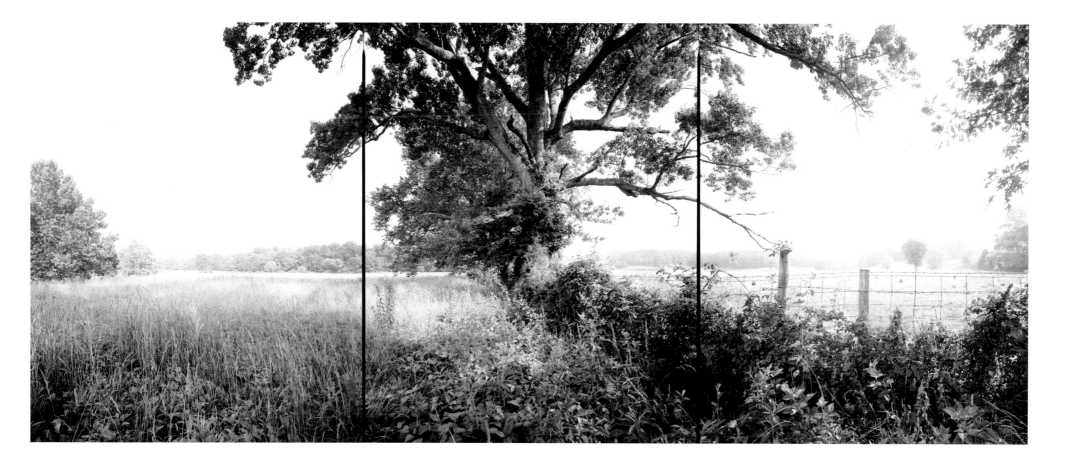

68. Western Larch, Montana, 1996

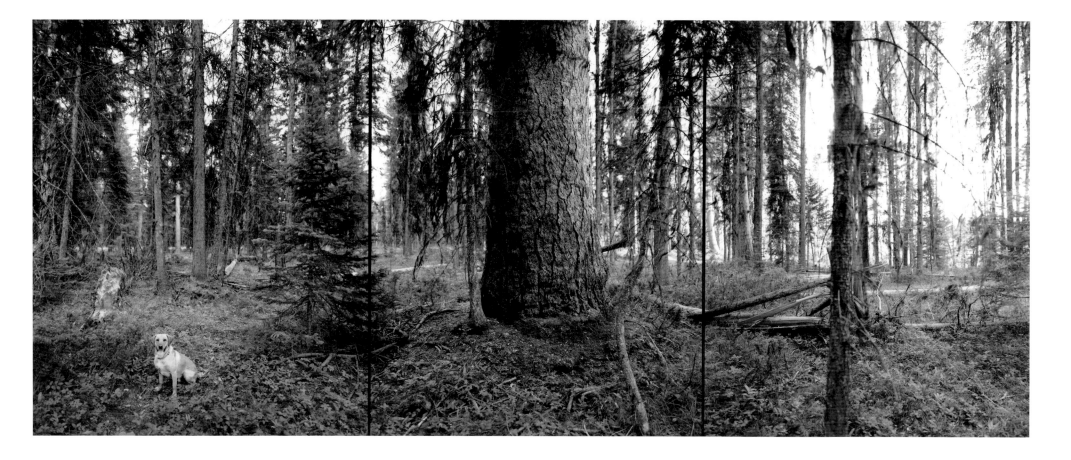

Lone Trees as Plain Champions

John R. Stilgoe

Photography transformed literary argument. Between about 1890 and 1940 professional and popular photographers recognized mature, relatively isolated trees as perfectly photogenic subjects. Eschewing explicit argument, such photographers indirectly emphasized that their photography differed from the snapshot sort done by amateurs using box cameras. Mature trees deserved, demanded, and rewarded sustained, accurate attention by photographers equipped with sophisticated cameras.

The mature tree in otherwise open country encouraged photographers to use it to order composition since they understood it as a dark, difficult form surrounded and suffused by light. Camera position shaped front or back lighting, shadow, and other density and path of light. At the turn of the twentieth century, photography magazines published expert advice concerning "the adjustment of masses" in landscape photography. "Landscape Photography," an April 1901 *Photo-Miniature* article, cautioned well-equipped photographers against compositions in which more than two masses appear, especially if each mass is a single tree. "If there are three or four separate masses, they must not be set off sharply one from another," argued the anonymous expert. "If there are more than three or four separate masses, the composition is a bad one." Such advice shaped even the most sophisticated photographic aesthetics. In a December 1900 *Photo-Era* article, Elizabeth B. Richardson asserted that great painters used "a certain underlying composition" that photographers must emulate: "a mass of high trees or architecture on one side, a lower mass on the other, with a valley, or a river, or a lake between them." Serious photographers accepted such serious, often stark advice, in large part because earlier tripod-mounted cameras employing wetplates restricted potential innovation. Each exposure cost time and money, and photographers tried to make each exposure as successful as possible. Such thinking shaped subsequent film-based efforts, but such efforts in time eroded earlier compositional orthodoxies.

Against compositional orthodoxy the Eastman Kodak Company advertised not only its box cameras but a variety of other cameras as well that might made either good snapshots or extremely fine photographs. In a 1910 booklet, *Motoring with a Kodak*, the firm explained the varying subjects motorists might encounter. Woods, hills, and other large-mass views do not figure in the booklet: Kodak told readers to aim cameras at such small-scale subjects as motorists stopped to picnic or lost and reading maps, or at bad roads or tirechanging scenes. By May 1927, when John L. Swayze published a *Photo-Era* article titled "Art and the Snapshot," professional and serious popular photographers realized that few amateur photographers valued greatly images that were "technically presentable" and "artistically graceful." Instead amateurs satisfied themselves with snapshots that recorded an event, and rarely aimed cameras at objects they found difficult to photograph. Woods overwhelmed them, as did individual trees. Almost certainly, as Frank A. Waugh implied in a January 1931 *Landscape Architecture* article titled "Ecology of the Roadside," too many motorists drove too fast to notice much more than the road ahead, and they rarely stopped to observe any landscape, let alone make photographs.

Publishers capitalized on motorists' inattention—and amateur photographers' inability—by producing editions of classic works illustrated with photographs. Houghton Mifflin's 1917 success, *Through the Year with Thoreau*, a volume of excerpts illustrated with photographs by Herbert W. Gleason, proved a prototype, but demonstrated too the difficulty of making photographs in masses of second-growth forest. At the same time, it and successor books made clear the technical and cultural difficulty of photographing lone trees. Photographs of single mature trees in champaign country raised too many enduring political, social, and aesthetic issues unmentioned in passages by Thoreau, Hawthorne, and other second-growth-forest New England writers cited at the beginning of the twenty-first century.

Photographing individual trees became what magazine experts, professional photographers, and critics deemed a "serious" image-making effort, requiring both superb equipment and superb skill. Equally important, photographing such trees placed American photographers—most known today only by the initials beneath their published images—squarely within an emerging British tradition that Washington Irving would have recognized immediately. Anyone reading entire runs of circa-1900 international photography magazines realizes that individual trees figure largely in prize-winning British photographs: British photographers went in search of great trees exactly as had the educated, early-nineteenth-century rural nobility that Irving studied. "The Lesson of the Chance Picture at the Salon," a January 1900 *Photo-Era* article, makes clear that British photographers valued mature trees—among other isolated landscape features—against cloud-filled skies and "broad, broken, expressive foreground" and "unimportant middle space." In the same issue, Denham W. Ross, a Harvard University lecturer on the theory of design, argued in "How Design Comes into Photography" that the design of a photographic composition must be consistent with the form of the ostensible subject. Working from cultural tradition and landscape-painting aesthetics, British photographers confronted the task of rendering lone mature trees or groups of mature trees in otherwise open countryside. According to published expertise, American photographers must follow the British lead.

By the second decade of the twentieth century, American photographers had begun to codify what they called "tree studies." While certainly a component of landscape photography, tree studies differed from images of forests or pastures or mountains. On the one hand, William S. Davis argued in a lengthy and precise July 1912 *Photo-Era* article, *tree studies* designates images made of single trees for scientific reasons, perhaps the cataloguing of the forms of different species or "their development at various seasons." On the other,

tree studies identifies lone-tree images made "from the pictorial standpoint." Some images might satisfy both the scientific record and the desire to make beautiful images, and can be achieved only from sustained effort. Technical mastery proves only partly important. The chief issue involves *realizing* the individual tree, especially the mature lone tree, in an aesthetic peculiar to it, the champaign country by then called *open*.

"Single specimens of trees often—one might say always—require more careful treatment to obtain the desirable quality of breadth than does an ordinary landscape where a number of trees are seen *en masse*," Davis insists. "Tree-Studies" endures as a critical essay in the history of photography, for it makes clear how much season, weather, and time of day—and always, character of light—affect the photography of individual mature trees standing in more or less open territory. An isolated tree becomes vastly more difficult to photograph than woods or the edge of fields and woods. It defeats snapshot photographers immediately, troubles all but serious non-professionals, and challenges even the most experienced professional photographers.

The lone mature tree or compact group of mature trees in otherwise open country stands outside of ordinary American landscape aesthetics and at the edge of photographic possibility. Davis argues that the single tree cannot be placed in straightforward compositions originating in balanced masses. The tree is its own mass, and stands beyond aesthetics involving other masses, large or small, and groups of masses. He counsels finding "an occult balance" when making the composition, and while he fails to define clearly his odd term, he implies that the tracery of the tree is its own balance.

Davis recognized the cultural difficulty with which many American photographers confronted individual trees, and the greater difficulty with which many viewers of photographs confronted images of such trees.

Lone trees have no easy place in American culture. They raise issues of land stewardship, time, history, class, family, and opposition to mainstream values few scholars and critics willingly discuss.

Lone trees champion intractable difficulties. The difficulties originate in the American cultural and aesthetic fascination with woods and forests that still shapes secondary school and university curricula, and that has long shaped the so-called mainstream of American literature. Teenagers and college students read Robert Frost's "The Road Not Taken" and write about roads diverging in the woods. In an urban age, generations after the settlement of the High Plains, second-growth forest orders the national landscape aesthetic. The fascination flaws the enduring but never wholly complete triumph of progress over conservatism. Always the lone trees speak of champaign country, of vast regions beyond the urbanized east and west coasts, and always the lone trees suggest that champions maintain values often out of fashion but at the core of cultural psyche.

Champion trees punctuate champaign country. Sugarberry in South Carolina, American elm in Kansas, Pacific madrone in California, even longbeak eucalyptus in Arizona rise from open land that long ago tormented lexicographers. Cartographers locate Champaign adjacent to Urbana. Long-distance motorists and Amtrak *City of New Orleans* passengers whiz through the Illinois university conurbation famous for its hyphen. Champaign-Urbana might denote the lawn-structure dichotomy vexing American city planning, but *champaign* slips free of context. The homophone now connotes a bubbly, sparkling wine, not the figure ground of trees, the campaign terrain of a photographer scrutinizing the National Champion common hackberry. Champagnelike befuddlement masks old meaning implicit in the great trees rendered here, but presentiment nonetheless shivers educated observers. Here we find trees that champion old causes once again on the campaign trail.

American high school students learn that two roads diverged in a yellow wood. As university undergraduates they learn of the forest beyond every Puritan town, and especially of the temptations and sins awaiting the unwary traveling meandering paths or probing trackless, grasping vegetation. Almost never do they learn of oak openings, intervals, and the champaign country where buffalo morphed from a woodland into a grassland species. Humanities instruction grows more urban-centric by the year, but its shrinking farm, plantation, and small-town component becomes ever more bewildered in romantic forest. The woods remain lonely, deep, and dark, and trees mass into nondescript shadows. Time past becomes time before: 1658 merges with 1743. The whole nineteenth century becomes 1830, then the era before electricity, automobiles, and—most importantly—cinematography. But the trees rendered here lived in the receding *then*, so difficult to glimpse in a metropolitan age that urges high school students to ruminate about diverging roads and life decisions but so rarely cites the grassy road the poet-narrator chooses.

Morality still skews the secondary school introduction to trees, forests, mountains, and the wilderness educators delineate as the abutter of colonial effort. "He had taken a dreary road, darkened by all the gloomiest trees of the forest, which barely stood aside to let the narrow path creep through, and closed immediately behind," writes Nathaniel Hawthorne in "Young Goodman Brown." For a century, schoolteachers have emphasized what Hawthorne mentions only in passing, that "the traveler knows not who may be concealed by the innumerable trunks and the thick boughs overhead." Warlike Indians may have concealed themselves, but a shadowy figure, representative of the devil, most certainly has, showing himself only when Brown turns a crook in the road. Dusk deepens, and unnerved by "ocular deception, assisted by the uncertain light," Brown strides, then shuffles into misadventure, myopia, and sin, succumbing to a

soul-eroding despair that sends him running into "the heart of the dark wilderness, still rushing onward with the instinct that guides mortal man to evil." All about him rises a cacophony of creaking trees, howling animals, screaming Indians, clanging church bells, and a roar that might be the audible scorn of nature itself. He stumbles into an infernal powwow, sees his revered neighbors serve Satan, and in the spectacle conceives a worldview everlastingly corrupt.

In 1846 Hawthorne wrote on the edge of change. Forest served him as setting and symbol, but in other tales, notably "My Kinsman, Major Molineaux," he chose the city, peopling urbana with strangers half seen in the dark. City life not only challenged rural attitudes and mores but reoriented philosophy and theology as well. Puritanism simultaneously slipped deeper into a past only fitfully revered: Hawthorne and others wondered at the wickedness of once-honored clerics and other public figures, and *The Scarlet Letter* addresses that depravity, again in a forest setting. But contemporaneous urban depravity and anonymity renewed interest in Puritan understanding of wickedness: university undergraduates routinely confront *The Scarlet Letter* but almost never read Herman Melville's urban-focused *Pierre, Or the Ambiguities*. Along with other ante bellum works, perhaps especially George Lippard's Gothic romance of Philadelphia, *Monks of Monk Hall*, *Pierre* raises too many issues of sexuality, violence, masquerade, and incest to fit easily into the post-1970s revised American literature curriculum. Concepts of time, the reach of the past, family, and land fit awkwardly by 1950, and by 1980 scarcely at all. "There is no surer method of arriving at the Hall of Fantasy than to throw one's self into the current of a theory," Hawthorne asserted in his 1843 "Hall of Fantasy," "for whatever landmarks of fact may be set up along the stream, there is a law of nature that impels it thither." Along with *Pierre*, "The Hall of Fantasy" goes largely unread, for its suggestion that "the white sunshine of actual life" must test every theory rattles all but the daguerreotypists and photographers

Hawthorne examined in his 1851 romance, *The House of the Seven Gables*. White sunshine, not dusk or shadowy starlight, fascinated artists confronting urbanization after 1840.

When John Greenleaf Whittier published "The City of a Day" in 1843, only antiquarians expected Satan in the New England forest. Everyone else knew the significance of Lowell. In Whittier's words, built "in a single night," the "chaos of brick masonry and painted shingles" existed because the "wizard of mechanism" had subdued rivers draining the White Mountains. The great dams, canals, and mill buildings, along with the dormitories, exemplified mechanical energy and—although Whittier wrote of it in subdued terms only—corporate capitalism. He hoped that mechanism might be raising the public "by wheel and pulley, steam and water-power, slowly up that inclined plane from whose top stretches the broad table-land of promise," but he could not be sure. After all, almost no mature trees graced Lowell.

Whittier compared the well-planned, new-built city unfavorably with New Haven and other older, small New England cities. The lack of "broad, spreading shade trees" in Lowell originates in the "characteristic utilitarianism of the first settlers, which swept so entirely away the green beauty of Nature." Instead of the elm-lined avenues of New Haven, Whittier walked "naked, treeless streets" in a summer as hot as Nebuchadnezzar's furnace. The corporate proprietors of Lowell had planted elm and maple saplings along some streets, but Whittier knew decades would pass before they shaded pedestrians. In the meantime, one grove of "fine old oaks" remained in the vicinity, "blending the cool rustle of their leaves with the din of machinery." Comprising "old, graceful colonnades" that made Whittier consider the past, then wonder how much true progress existed in the white sunshine of Lowell, the grove of oaks standing before industry triumphant epitomizes the changes Hawthorne and other writers addressed.

Europeans sometimes saw what Hawthorne, Whittier, and other locals missed. In his 1844 *Letters from America*, John Robert Godley marveled that the road from Boston to Lowell, the most well traveled in the nation, "is bordered for the most part by a wilderness which does not bear, apparently, a trace of man's proximity." Godley knew exactly what bordered the road: second-growth woods. Land occupied 230 years earlier had been exhausted, and often abandoned or disused by individuals and families moving west, going to sea, or searching for work in Boston and other cities, even in the tidewater South. Godley knew that New Englanders had been moving to Virginia and other southern states to farm land abandoned by growers of tobacco and cotton, and he suspected that until all the fertile land of North America had been settled and cultivated most industrious farmers would eschew the stony ground and harsh climate of eastern New England. Godley did not exactly envision the suburbanization of Boston, but he did realize that the Boston-Lowell corridor, which would soon host a railroad, then a telegraph line, as well as a very busy highway, ran through dense second-growth woods that prompted him to consider the meaning of wealth in a time of change.

Unlike Whittier, Godley grappled with the growing distinction between the Party of Permanence and the Party of Progression. The former he saw in traditional British terms: the so-called landed interests favored gradual change at best, and always understood real wealth to be land, and perhaps the crops it produced. To the Party of Progression belonged the "mercantile, manufacturing, and professional classes" whose star had begun to rise extremely quickly, if Lowell proved any reliable indicator. Godley accepted the simple reality he found everywhere: many farmers saw their farms as investments, not transgenerational family seats, and had as much a "go-ahead" as any manufacturer. Moreover, southern plantation owners seemed the most opposed to the Party of Progression, and expressed their contempt in Congressional debates about tariffs especially. The

afforested land that hemmed the Boston-Lowell highway made Godley extremely thoughtful about the long-term meaning of wealth in a nation dividing along what others thought of as sectional lines. The Party of Progression envied its opponent enough to buy land with its profits, but it might never achieve a land-centered outlook that would protect both the national polity and the poor. Whatever the ills of southern slavery, the planters at least paid lip service to their lifelong responsibility for slaves they did not sell. Godley wondered who—or what corporation—felt any lifelong responsibility for the mill workers of Lowell. The second-growth forest lining not a footpath but a busy highway suggested that in New England even the Party of Permanence moved away from exhausted soil rather than restoring it to fertility.

In the 1840s and 1850s run-up to the Civil War, many able writers blended the primeval forest encountered by the first colonists with the second-growth one covering much of the seaboard north of Virginia. High school and university students rarely imagine that Hawthorne's Brown might be seduced away from agrarian virtue and other riches, including his devoted wife, Faith, by a recruiter for Lowell mill owners. Almost never do they read any of Whittier's essays on Lowell, so they almost never put his best-known poem, "Snow-Bound" into any context other than a three-day blizzard. Melville's *Pierre* rewards scrutiny, but it stuns contemporary sensibilities: the young people seeking urban excitement find far more than most twentieth-first-century readers prefer to imagine. That Hawthorne, Whittier, and Melville all realized corporate industrialism prospering in second-growth forest remains a well-kept secret, perhaps because other American writers anticipated Godley's tough-minded scrutiny of second-growth forest and the class and family divisions such woods suggested.

In his 1847 "Patucket Falls," another of his Lowell essays, Whittier concludes his analysis of change by quoting a description

of a lightning-struck oak plunging down the falls bordered by mills. The great tree is gone. Eleven years later, in "Slavery in Massachusetts," Henry David Thoreau argued that "it is evident that there are, in this Commonwealth at least, two parties, becoming more and more distinct." But he meant something utterly different than the proslavery and abolitionist division that was the focus of his essay. He saw a division between "the party of the city, and the party of the country," and he determined not only that the latter had more of value about it, but that it had begun to drown in urban-based journalism. He explicitly suggested an "assault on the press," for the "press is, almost without exception, corrupt," especially when dealing with rural issues. "I believe that in this country the press exerts a greater and a more pernicious influence than the church did in its worst period," he argued in a passage few contemporary readers associate with Hawthorne's fixation on temptation and sin in second-growth forest. As Thoreau and his contemporaries worried about preserving the Union while abolishing slavery, they worried too about the vanquished champions of yore.

In one of his least-remembered tales, Hawthorne describes a half-apocryphal collision between Sir Edmund Andros, the royal governor appointed by James II, and a nameless elderly man drawn from the country to Boston by rumors of tyranny and misrule. In his old Puritan clothing of dark cloak and high-crowned hat, sword at his side, staff in hand, the elderly man materializes in the empty street ahead of the royal party and its military escort, then walks slowly toward authority, seemingly growing taller with each step. After a moment, his will masters that of the governor, who orders his party backward in what becomes a retreat that led to his arrest by the citizenry. According to Hawthorne, people saw the man again at Concord on April 19, 1775, and subsequently at Bunker Hill. "I have heard, that whenever the descendants of the Puritans are to show the spirit of their sires, the old man appears again,"

Hawthorne concludes of the champion whose "shadowy march, on the eve of danger, must ever be the pledge, that New England's sons will vindicate their ancestry." The old man comes from the country, becoming the vertical element on a street, then in fields, then on a bare hilltop, all of which lack trees. Of far less certainty is his identity, at least beyond the tale. In rural legend, he is a convicted regicide escaped to New England after the succession of Charles II a hundred years earlier. From the country come champions who kill kings.

In a way especially important in the years leading to the Civil War and the economic divisions that immediately succeeded it in the so-called Gilded Age, the country is champion land. In rural places, even places covered with second-growth woods, lives the spirit of Puritanism or liberty or stability, or whatever virtue some party desires at a given moment to counter what Hawthorne defines as "darkness, adversity, and peril." And because trees outlive people, often by many centuries, trees become the monitors and witnesses to champions, if not the empowering force of champions. Trees share some mysterious energy with those who work among them, and especially those who plant trees. As Clifford Shipton makes clear in his *New England Life in the Eighteenth Century*, country people believed that a tree planted by someone subsequently absent from its vicinity announced by its condition the health and prosperity of its planter. Moreover, long after its planter's death, it memorialized permanence, far-seeing, and other virtues implicit in tree planting. When Jonathan Frye left to join Lovewell's Rangers in the 1725 war with Quebec, he planted an elm tree: his descendants guarded and cherished the tree until it died a century later. Its death produced a newspaper story in the *Columbian Centinel* on May 25, 1825, for the elm had been a direct link with the fighting chaplain killed in the Pigwacket Fight, one of the bitterest battles in New England history.

Trees outlive even champions, standing witness to elder greatness the craven ignore.

New England authors continue to represent the main-traveled road of American literature for all that secondary school and university curricular changes diminish their importance. New York and southern authors represent a grassy road much less taken, and nowadays almost unknown. Washington Irving and James Fenimore Cooper offer a view of trees, especially mature trees valued by people who live near them, that informs much New England thinking but remains peculiar to an old middle-states viewpoint deliberately obscured by 1930s curriculum reformers. Their view of trees exists today almost as unread as the work of Thomas Nelson Page and other southern writers who saw mature trees shading and symbolizing what Godley termed the Party of Permanence.

In 1822 Irving differentiated between genuine and upstart permanence, using the English countryside as a mirror for the American version. Any newly rich family might raise a monumental house of stone and marble, he argued in *Bracebridge Hall*, for even fine buildings are the work of a day. But only long-established families enjoy the mature trees planted by their ancestors, especially the colonnades of "stately oaks," elms, and other slow-growing trees that eventually make people beneath them become "mere pigmies." In a chapter titled "Forest Trees," Irving details how the English rural nobility cherish family trees, and even travel to see great trees. "It seems that trees, like horses, have their established points of excellence," Irving concluded, "and that there are some in England which enjoy very extensive celebrity among tree-fanciers, from being perfect in their kind." Appreciation of trees manifests itself in precise discrimination: Irving asserted that English love of landscape scenery and devotion to sustainable and restorative agricultural techniques originated in full realization of mature trees that punctuated other-wise open country or lined drives leading to homes long in the possession of individual families. Mature trees exemplify love of land, love of landscape, and love of permanence.

Despite being raised with "republican principles and habits," Irving finally admitted that he was "neither churl nor bigot" in his beliefs. "I can both see and feel how hereditary distinction, when it falls to the lot of a generous mind, may elevate that mind into true nobility," he asserted in a passage he knew would find disfavor among many of his fellow citizens. Across much of rural England, old families understood that heredity "extends the existence of the possessor. He does not feel himself a mere individual link in creation, responsible only for his own brief term of being." Instead the country squire "lives both with his ancestry, and he lives with his posterity." Family land and mature trees site and shade him in a particular way. The mature oak planted by an ancestor and intended to shade generations unborn "is an emblem of what a true nobleman *should be*; a refuge for the weak, a shelter for the oppressed, a defense for the defenseless; warding off from them the peltings of the storm, or the scorching rays of an arbitrary power." Mature trees remind the thoughtful country squire that his identity originates in both place and family, and that place and family weld into something more powerful than daily winds of change.

Mature trees remind the thoughtful American traveler that revolution by definition destroys a permanence in which trees thrive across human generations.

What worried Irving incensed Cooper. In two 1838 novels, *Homeward Bound* and *Home As Found*, Cooper lambasted recent changes in United States society, particularly the land speculation he claimed destroyed both soil fertility and rural and village culture. A year earlier, he published *Gleanings in Europe*; like Irving, Cooper valued stability, and he found precious little when he returned to New York. "'It is getting to be a predominant feeling in the American

nature, I fear, to love change,'" remarks one thoughtful character in *Home As Found*. Too many well-to-do families expanded their houses at the expense of adjacent trees, or felled great trees so that passersby might more easily see new and grand houses. Only a handful of old-money families valued old houses long in individual families, well-managed farm land immune from speculation, and great trees with family and historical association. "A lovely place, that was beautifully shaded by old oaks, and on which stood a rude house that was much dilapidated," commands far higher value in Cooper's moral aesthetic than the large, new, and unshaded houses facing the Hudson River.

Scathing attacks on Jacksonian culture eventually consigned Cooper's novels and nonfiction to library dust: the withering and accurate scorn Cooper heaped upon a rapidly changing nation produced contemporaneous counterattack worsened by growing sectionalism. Southerners often agreed with Irving and Cooper, arguing that plantation life represented a modernist and stable transplantation of English country life to the New World. Land and stock market speculation, industrialization, urban disjunction, and grating economic uncertainty, especially for the working poor, seemed worse when southerners identified them as northern problems. Already an icon of permanency in much American writing about England and Europe, mature trees slowly became not only an icon of permanence in the north, but a symbol of stability across the south.

When William Gilmore Simms published *The Yemassee* in 1835, the South Carolinian knew well the power of mature trees as icons of permanence. Set in the year 1715, the historical romance focuses on colonist-Indian disputes, but some of the colonists live on what Simms describes as family estates. "Embowered in trees, with a gentle esplanade running down to the river, stood the pretty yet modest cottage" in which the action begins. "The dwelling was prettily enclosed with sheltering groves—through which, at spots here and there, peered forth its well whitewashed verandah." Already the house boasts a "portico of four columns" which Simms condemns as an "excrescence," but already too it boasts mature trees and groves. While the estate is not centuries old, its trees are, and the trees indicate aesthetic decision originating in clear understanding of permanence. Twelve decades later, Simms most definitely realized, readers would imagine the same estate having an enlarged house set among the same great trees.

Irving, Cooper, Simms, and other writers now often dismissed as second rate and rarely introduced beyond their "best-known works" typically wrote from a clear understanding that social, cultural, and political permanence offered any nation distinct advantages. In the first decades of the Republic, uncertainty vexed many thoughtful Americans: the War of 1812 produced the Hartford Convention of 1815 in which New England considered seceding from the Union; the next two decades produced bitter sectional disputes about tariffs, nascent manufacturing, urbanization, immigration, financial panics, and, like a fire bell in the night, slavery and abolition, always in the convoluted context of westward expansion that threatened war with Mexico and other powers. More than most of his contemporaries, Cooper lambasted disordered change, and more than most he recognized the ferocity with which many of his fellow citizens championed stability.

European scenery and post–Napoleonic War cultural stability remains the nearly invisible backdrop of much antebellum United States writing, especially that deliberately ignored today. In 1858, for example, Hawthorne visited the Villa Pamfili in Italy, the residence of a prince who intermittently opened his grounds to visitors. "We rambled among these beautiful groves, admiring the live-oak trees, and the stone pines, which latter are truly a majestic tree, with tall columnar stems, supporting a cloud-like density of boughs far aloft, and not a straggling branch between them and the ground." The

trees are old, almost magically so. "They stand in straight rows, but are now so ancient and venerable as to have lost the formal look of a plantation, and seem like a wood that might have arranged itself almost of its own will. Beneath them is a flower-strewn turf, quite free of underbrush." Hawthorne wandered in royal champaign grounds, among family trees that bespoke and championed stability and an aesthetic sensibility increasingly rare at home. At the Villa Pamfili, he encountered the arboreal intensity that eventually split his countrymen: most Americans valued forest, usually for wood and the prospect of farmland cleared from it, but upper-class, long-range thinkers tended to value mature trees in champaign country. On the eve of civil war, some Americans understood the relation of stability and landowning.

Cooper bridged both camps, for early on he descried the cultural conundrum prairies posed to a culture evolved in forest. He wrote *The Prairie* in France in 1827. One of the novels that comprise his so-called leatherstocking tales, it addresses the role of United States citizens in the vast grasslands of the upper Mississippi basin, and it remains one of his few novels read today. But however prescient, it deals with an issue Cooper revisited in the late 1840s, when he published *The Oak Openings: or, The Bee-Hunter.* Cooper did as Simms did in *The Yemassee*: he set the action in an earlier age. But Cooper looked back only to 1812, not more than a century, to a moment when most Americans had fixated on the war with Great Britain, not on the potential of the Michigan Country. There pioneers encountered the miniature prairies they first called *openings*, for they understood them as great glades, not the serrated western edge of the Atlantic forest.

The grassland struck its explorers as essentially infertile, simply because it seemed to produce few or no trees. Cooper understood this fallacious view well enough in 1827, but over the next twenty years he grasped the deep cultural wrenching that began in what

became the state of Michigan. "There is nothing imaginary in the fertility of the west," he wrote in the preface to *The Oak Openings.* "Personal observation has satisfied us that it much surpasses anything that exists in the Atlantic states, unless in exceptions, through the agency of great care and high manuring, or in instances of peculiar natural soil." Such passages demonstrate a deep understanding that some families (or like-minded successive owners of pieces of land) maintained soil fertility and income over generations through manuring and other techniques, but that most arable land slid into the abandonment and second growth that bemused Godley on the road to Lowell. As early as the 1820s, Cooper knew too that in country lacking trees, even the least thoughtful of pioneers might fell most trees but leave the finest. West of Michigan, Cooper asserted, only houses would indicate stability, at least for decades, except for the few homes shaded by rare outstanding trees. Beyond champaign country, pioneers might deride all grass-covered soil as infertile, and push along the Oregon Trail to forest land.

"The leaf is as much beyond our comprehension of remote causes, as much a subject of intelligent admiration, as the tree which bears it," Cooper writes in the first chapter of *The Oak Openings.* "The single tree confounds our knowledge and researches the same as an entire forest: and, though a variety that appears to be endless pervades the world, the same admirable adaptation of means to ends, the same bountiful forethought, and the same benevolent wisdom, are to be found in the acorn, as in the gnarled branch on which it grows." In almost the first words of his novel, Cooper fastens on an inveigling intellectual problem. What happens when the people of the forest confront not prairie, but lone trees punctuating champaign country?

Cooper argued from an aesthetic rooted in England and the Continent. "Although wooded," the Michigan country "was not, as the American forest is wont to grow, with tall straight trees towering

toward the light, but with intervals between the low oaks that were scattered profusely over the view, and with much of that air of negligence that one is apt to see in grounds, where art is made to assume the character of nature." This critically important passage demonstrates the prize Cooper—and Irving, Hawthorne, and other early-nineteenth-century writers—found on the far side of the ocean. At the Villa Pamfili and elsewhere, they discovered an aesthetic that shaped their realization that some wilderness might duplicate landscape shaped over centuries by families looking toward past and future simultaneously. Champaign country is a natural prize in a Republic, if undervalued by the settlers of Michigan.

In the openings, bur oak woods "possess a general character of sameness," Cooper continued. "The trees were of very uniform size, being little taller than pear-trees, which they resemble a good deal in form; and having trunks that rarely attain two feet in diameter." Anyone moving into the openings discovered that "variety is produced by distribution," for in some places the trees "stand with a regularity resembling that of an orchard." Elsewhere "they are more scattered and less formal, while wide breadths of land are occasionally seen in which they stand in copses, with vacant spaces, that bear no small affinity to artificial lawns, being covered with verdure." The rolling countryside may not be natural: Cooper states that Indians might have created it accidentally through repeated burning. But it is open enough for the bee hunter to track the flight of bees toward their hives, and to follow the flight paths easily across miles of openness.

Unlike most other Cooper novels, *The Oak Openings* concludes with a chapter describing the region in 1847. Near Prairie Round, an Americanized version of *la prairie ronde*, Cooper found an "oval plain of some five-and-twenty or thirty thousand acres," by then fenced, farmed, and punctuated with houses and barns. But at its center was an "'island' of forest, containing some five or six hundred acres of the noblest native trees we remember ever to have seen," itself surrounding a little lake of about a quarter-mile diameter. Cooper emphasized that the woods are "not an Opening, but an old-fashioned virgin forest," and are owned by a meditative man, one of the heroes of the novel, who "kept clear of the whirlwind of speculation that passed over this region some ten or fifteen years since." The head of the family is about seventy, lives surrounded by "fine descendants," and "his means are ample." He and his life appear stable and reputable to anyone who finds that he has preserved a few hundred acres of virgin forest in the midst of prairie: preserving the trees originates in valuing stability. In the oak openings, a tiny forest and individual trees become vastly more important than extensive woods.

Perhaps more than any other antebellum observer, Cooper understood that in champaign country, trees focused attention. A lone tree or a copse first offered some notion of scale and distance to explorers. To anyone looking about at a sea of grass, a tree or cluster of trees provided some sense of time past too: unlike the grass, trees offered accessible if rough indication of age. But Cooper knew too that in champaign country trees reminded only the learned and traveled—if traveled only in books—of the stately trees of England, France, Italy, and other countries where itinerant and expatriate Americans pondered stability, family, and heredity responsibility. Most Americans thought nothing of such matters, and in the Civil War era often moved as rapidly as possible across the treeless plains of the Great West.

In the 1820s Cooper understood that grassland bereft of trees symbolized infertility to most pioneers, and that the bur oaks of Michigan reassured westward-moving families that the adjacent grassland would prove profitable. Cooper enjoyed traveling by railroad, but he died before the post–Civil War era in which railroad companies lured Scandinavian and other European farm families to the treeless expanses west of the Mississippi and Missouri. Many

native-born American farm families continued to focus on the Oregon country or the valleys of California, passing across the plains by rail to start farming anew in country covered or punctuated with trees.

Scholars rarely focus on the viewpoint of Irving, Simms, and, especially, of Cooper when analyzing either antebellum American culture, especially landscape aesthetics and social class, or deforestation for agricultural, industrial, and domestic uses. As Michael Williams demonstrates in "Clearing the United States Forests: The Pivotal Years 1810–1869," a January 1982 *Journal of Historical Geography* article, after the 1820s technological "take-off," vast regions of the country transformed within a few years from forest to denuded landscape, sometimes farmed, often abandoned to the haphazard afforestation Godley examined. Anyone accepting Williams's data eventually understands that preserved mature trees and groves often appeared like apparitions in logged-over or industrialized locales. What Whittier found in Lowell and Cooper in Round Prairie proved the first indications of what became the late-nineteenth-century conservation movement, but what in their own time often epitomized political, social, cultural, and—frequently—old-money family conservatism. Forest fascinated Hawthorne, and his view dominates United States humanities education to this day. Trees, copses, and—particularly—mature trees and groves of mature trees fascinated Cooper and many other observers now mostly forgotten.

Antebellum deforestation produced a division in American culture every bit as deep as issues that engendered civil war. In the minds of many, mature trees championed stewardship, family, and permanence in a time of rapid, grating change. After the Civil War, mature trees championed values greater than the money-grubbing, financial speculation, and modernization that defined the Gilded Age. They emblemized the defeat of the Confederacy and the enduring triumph of a near-vanquished way of life.

In the Gilded Age most American intellectuals turned their attention to cities, industrialization, and to the settlement of the High Plains and West Coast. Victorious northerners shaped the content of national magazines and advertising, and even schoolbooks and university curricula. Not until the 1890s did many realize that "the old South" had emerged in art as a counterbalance to forces most intellectuals accepted as progress. In the decades-long conservationist prologue that culminated in Arbor Day in 1911, the old South became the region that prized old trees as champions of values that endured defeat.

Well before the Civil War, southern writers emphasized that mature trees symbolized a love of land Cooper thought characterized only the most conservative, deep-thinking northerners. "Between the gate and the house a large willow spreads its arched and pendent drapery over the grass," wrote John Pendleton Kennedy in his 1832 novel *Swallow Barn*. Nearby "an aged sycamore twists its roots into a grotesque framework to the pure mirror of a spring." Trees and woods vary the scenery of the plantation: a screen of Lombardy poplars blocks views of the stable, clumps of pine and dwarf oak interrupt the broad fields of corn, cotton, and tobacco, and laurel and alder mark the confluence of a creek and the James River. But the mature trees accentuate the "aristocratical old edifice," the "time-honored mansion" that suggests permanency and "the idea of comfort in the ample space" it fills. The present owner "thinks lightly of the mercantile interest, and in fact, undervalues the manners of the large cities generally," scarcely travels outside Virginia and certainly never to New England, and enjoys "the solitary elevation of a country gentleman, well to do in the world." The gigantic willow and sycamore focus the reader on the timelessness of the plantation, but Kennedy makes clear the connection between their solitary loftiness and that of the country gentleman who resembles those Irving and Hawthorne met in Britain.

Swallow Barn reappeared in 1853, as southerners countered the abolitionist portrait of plantation life and economy grounded in slavery. New printings occurred in 1860 and in 1865, bracketing the war that destroyed the life its author depicted. More than its romantic plot made *Swallow Barn* a perennial favorite. It focused on issues that paradoxically became more vexing in the decades following the Civil War. As the Party of Progression led the republic into situations that caused many thoughtful intellectuals to glance backward at the mature trees that suggested permanence, the antebellum South became a romanticized counterpoint to modernization, and especially to industrial capitalism.

One southern author after another emphasized this even during Reconstruction. "Half hid by the avenue of willows" reaching between it and its nine-mile view of the Mississippi, the great house of Belles Demoiselles Plantation figures largely in George Washington Cable's 1879 *Old Creole Days*. Approached at night from inland, through a clump of live oaks, "it looked so like a gem, shining through its dark grove, so like a great glow-worm in the dense foliage, so significant of luxury and gayety," that its owner groaned with responsibility. Deeply in debt since the war, fighting off land speculators who wanted to buy the plantation, he recalls his lineage and screws up his courage to confront rapacious speculators. "It rose straight up, up, up, generation after generation, tall, branchless, slender, palm-like." Cable says of a tree that symbolizes family responsibility. In *Old Creole Days* "old Colonel De Charleu" understands himself in terms of the mature trees that grace his mortgaged plantation: like the trees, he has a history, and his history is rooted deeply and only in a particular piece of ground.

By 1900 such views had become commonplace, not merely in the former Confederacy but everywhere in national literature. The romanticism of Kennedy and other prewar writers made way for a new aesthetic and value system grounded in defeat, loss, and poverty that nonetheless shoved against issues of urbanism, corporate capitalism, and economic uncertainty. Following the calamitous financial panics of the 1890s, many northerners discovered themselves in the economic position of southerners in 1865, and many more realized the impermanence of wealth based in stocks, bonds, and savings accounts. In the late 1890s national magazines ran story after story suggesting that the South held the key to cultural and psychological security that transcends military defeat and modernization.

"An old gentleman, who had paused just outside his broken gate, and turning half around, was now standing looking back at the trees behind him," wrote Thomas Nelson Page in 1901 in *The Old Gentleman of the Black Stock*. The young narrator looks at the ancient trees in front of the ruined townhouse. "There were three or four big locusts, two wide-branching elms, and one beech, all large and very old, and the beech quite gigantic." The young man muses that the beech might be "the sole relic of the primeval forest which once had clad these hills" and as he notices initials carved into its "hoary bark" he understands that "it had known of other times far back." He speaks to the elderly man, who replies that trees are worth loving. "They last."

Once recognized, the place of mature trees in an aesthetic and value structure contradicting modernization becomes evident in much post-1900 southern writing that reached a national readership. In much writing, disdain for mature trees, especially failure to care for them, indicates moral failure. Page's 1887 *In Ole Virginia* forces any reader to notice the juxtaposition of the dilapidated plantation houses "set back far from the road, in proud seclusion, among groves of oak and hickory" against the fields grown up in sassafras. Any reader of James Lane Allen's novel of 1900, *The Reign of Law: A Tale of the Kentucky Hemp Fields*, realizes that the bitterness of a family dispute involving the felling of trees to grow more hemp originates in a clash between values of land stewardship and desire for

short-term profit. By the beginning of the twentieth century, southern writers had located mature trees at the center of an alternative philosophy.

No twentieth-century writer embraced that philosophy more subtly than Ellen Glasgow, a southern writer who rose to international prominence. When she died in 1945 she had rescued southern writing from the fallacies implicit in so much romanticized "lost cause" fiction focused on the Civil War, and had placed the modern south within a context of national economic and cultural change. Her 1908 novel, *The Ancient Law*, opens with a traveler encountering an old plantation house rendered almost unapproachable by "the prostrate forms of giant cedars." The debt-ridden owner of Cedar Hill has cut down the immense cedars to sell as saw logs. Such modernist innovation strikes Glasgow as not necessarily wrong: perhaps the trees bind the owner to a past that enslaves the will. In *The Miller of Old Church* three years later, she remarks that "the square old house, with its hooded roof and its vacant windows, assumed a sinister and inhospitable look against the background of oaks." For some families, mature trees had become the equivalent of sassafras-smothered abandoned fields in the writing of Page and other lesser thinkers. For others, including the women-only household in her 1925 masterpiece *Broomsedge*, mature trees represented a stability that gave courage to people struggling to make arable fields from second-growth scrub. "The farm belonged to her, and the knowledge aroused a fierce sense of possession. To protect, to lift up, rebuild and restore, these impulses formed the deepest obligation that her nature could feel." In the roaring twenties such impulses struck many urban Americans as backward, if not hokey, but Dorinda slowly overcomes her depression and realizes the worth of the mature trees. "The trees were bare overhead," after a night of storm and nightmare. "Against the eastern sky the boughs of the harp-shaped pine were emblazoned in gold." Dorinda walks from her shabby house along the tree-lined path and realizes the strength of the spirit of the land and the long-term meaning of mature trees that endure and triumph across human generations and catastrophic human displacement. Glasgow understood the lesson of permanence implicit in the trees that endured the pioneering epoch, the Civil War, Reconstruction, and late-nineteenth-century financial panic, then the Roaring Twenties and the Great Depression. She understood the mature trees are the watchers of human triumph and heartbreak.

Between the 1870s and about 1915, southern writers reshaped much northern thinking about culture, economics, and landscape. Mainstream northern attention remained focused on woods and forests, not individual trees: Ernest Bruncken's 1900 *North American Forests and Forestry: Their Relations to the National Life of the American People* and Joseph Ise's 1920 *The United States Forest Policy* exemplify a mindset and massive body of literature understanding woods and forests as commodity first and cultural resource second. Northern writers focused on scenery tended to think of trees in masses, especially on hillsides, and frequently identified a mix of second- and third-growth forest and primeval trees as mere woods. Even the most prominent and nuanced of the so-called nature writers recoiled from the cultural, political, and economic ramifications implicit in woods versus trees thinking. "The Yankee, with his proverbial thriftiness and forecast, appears entirely to lose these gifts when it comes to the proper and sensible management of woodlands," opined Rowland E. Robinson in his 1896 *In New England Fields and Woods*. But the native view somehow skewed that of immigrant farmers: "our foreign-born landholders, being unused to so much woodland, think there can be no end to it, let them slash away as they will." While most nature writers understood forest as habitat, especially for fish and other game valued by upper-class outdoors people, at least a few realized that distinguishing between caring for

woods and caring for great trees raised troubling issues dating to the era of Irving and Cooper. Immigrants seldom learned about great trees, family, and the Party of Permanence from northerners, for immigrants rarely confronted the champaign country in which great trees demanded attention, and even less often encountered people who understood mature trees as many southerners did. After its Civil War triumph, the north committed itself to the Party of Progression, and by 1900 found Irving, Cooper, and like-minded other northern thinkers as vaguely disturbing as Kennedy, Cable, and Page. Glasgow debuted as an irritant, then in the Depression became a voice so powerful universities still muffle it.

Seeing Through Trees

Douglas R. Nickel

Trees smell good, feel good, sound good, and look good. And as if that weren't enough, they point beyond themselves.
—Robert Adams, *Cottonwoods*, 1993

I.

The National Champion Tree program was inaugurated in 1940. There must have been something in the air that year, for America witnessed a proliferation of contests at the time that seemed to share a common impulse. A group of civic boosters from Atlantic City, New Jersey, moved their annual swimsuit tournament to Convention Hall in 1940 and renamed it the Miss America Pageant. In May, 1940, the first Mr. America, John C. Grimek, was selected from a field of body-builders competing in New York.[1] Trees, beauty queens, and muscle-men had more in common than we might imagine. The premise behind the National Register of Big Trees was to find and document the largest known example of every native or naturalized tree in the United States: the most ample specimen produced is designated the champion tree of that species, and its general location registered. Like their human counterparts, rival trees came from around the country, and vital statistics—circumference, height, and crown spread, in this case—determined their success (figure 1). All three contests emerged from the Depression, with support from the private sector: companies such as Catalina Swinwear helped subsidize the beauty pageant in its early days, while the National Register found support through a conservation group called the American Forestry Association.[2] More significantly, the competitions were organized around tenets that were already fairly venerable by 1940. Mr. America touted an exaggerated and unrealistic version of male anatomy. Miss America projected a pre-suffrage ideal of womanhood to the nation: its winsome contestants were meant to exemplify youth, feminine beauty, innocence, and demure deportment.[3] With the trees, what was valued was size.

Figure 1 Measuring a Tree on Flat Ground. Illustration from Robert Van Pelt, *Champion Trees of Washington State* (1996), p. ix.

As an artifact borne of early thinking about the environment that survived into more enlightened times, the Big Trees program today stands as a hybrid proposition, and thus raises some questions. What part of our national psyche kindles this obsession with magnitude—be it a conifer or a champion pumpkin at the state fair? What did it mean, historically, to value a tree for its size alone—and not, say, for its age or its looks? Why anoint the exceptional individual of a species when the goal would seem to be preservation of the group and its habitat? What might it mean, in our day and age, to turn trees into champions? And what else (in Robert Adams's apt formulation) can trees point to?

As it happens, an abiding interest in the magnitude of trees separates American attitudes toward the subject from those of the Old World. Because we share a common cultural heritage with Europe, this difference is not absolute: the emblematic or archetypal associations that the tree carried with it became part of our inheritance as

well, if only latent. In the Judeo-Christian tradition, the Garden of Eden sustained two trees, the Tree of Life and the Tree of Knowledge. The latter—source of the fruit Eve offers Adam—seems to command attention in the narrative, but the Tree of Life is, as a symbol, just as essential. The ancient peoples of Sumeria and Mesopotamia carved stone relief tablets depicting their gods ritualistically tending to date palms: in that arid corner of the globe, the tree was not merely decorative or naturally occurring in the landscape, but a cultivated source of honey, bread, fruit, and even a type of wine. Pliny, in his *Natural History*, explained how the date palm produces food over a long harvest season (July to November), and hands down to posterity the apocryphal contention that a new frond spontaneously regenerates wherever a dead one drops. Indeed, as Simon Schama notes, the words "palm" and "phoenix" are interchangeable in ancient Greek—the Tree of Life thus carried with it associations with rebirth, resurrection, and immortality.[4] The Canaanites brought the mythologies of the Ancient Near East back to the Holy Lands and to the Hebrew Bible: we read in Genesis how God revokes Adam and Eve's access to the Tree of Life, that is, to immortality, as punishment for their disobedience. In the Christian tradition, this expulsion is countermanded by the cross on which Jesus—the new Adam—dies, an apparatus some believed to have been fashioned of wood from the Tree of Life.[5] Pilgrim flasks from fifth- and sixth-century Palestine show the cross, emblem of eternal life, as a palm tree.[6]

As the Church spread throughout early Europe, it constructed its churches knowingly on the sites of the sacred groves worshipped by pagan incumbents. The Druids believed the spirits of the dead dwelled in the hollow interiors of old oak trees; in some etymologies, the Celtic "dru-wid" means, literally, "knower of the tree." Likewise, the yew tree was venerated as a symbol of immortality in Celtic cultures; yews can still be found in the graveyards of many old English churches, generating new life from the moldering remains beneath their roots. Rather than stamping out the fertility rites and tree worship of its newest converts, however, Christianity often absorbed their symbols into its own program. In the Roman myth, Atys, driven to madness by Cybele, mutilates himself and is transformed by Jupiter into an evergreen tree. Imperial Rome celebrated the seasonal cycle of death and renewal at the spring equinox, when dendrophors—ritual tree bearers—were sent to the woods outside the city to fell and retrieve a sacred pine. The tree was garlanded with flowers, pig's blood was consumed, and bread eaten, in a ritual representing the sacrifice of the blood and body of Atys. Today, many around the world observe the birth of Christ with an evergreen tree, and his death and resurrection in the spring with the rite of the Eucharist performed under the emblematic cross.[7]

Trees were therefore meaningful to the Old World amalgamation of heathen idolatry, classical literature, and Christian iconography. Yet the European tradition paid no particular attention to a tree's physical proportions. Its archetypal valence derived from its botanical shape and function: roots in the earth, crown in the heavens, and a trunk uniting the two. As a defining quality in popular appreciation of trees, the modern reverence for size was chiefly a product of the American West.

The California Gold Rush of 1848 drew legions of prospectors to the Sierra Nevada in search of overnight fortune, and while it was the rare individual who actually came out of the mountains with appreciable amounts of gold, many more returned with a newfound competence for spinning tall tales. Augustus T. Dowd was hunting in the hills above Murphy's Flat in the spring of 1852 when the bear he was tracking led him to the location of the Calaveras Grove of giant sequoias. When he later told some dinner companions that he had discovered a redwood tree of stupefying proportions, they dismissed the account as one of his excellent evening entertainments.

Determined to restore his credibility, Dowd revisited his tree and circumnavigated the trunk with a piece of string. A week later he had his companions measure it—the girth came out to some one hundred feet. But as one of the party quickly noted, this was no proof at all; Dowd could just as easily have wrapped the string around a cabin. The claimant had no choice but to take his critics to the spot—a proposal that was met with interest by the men, several of whom worked for the lumber mill in Murphy's. After some difficulty retracing the route, Dowd was finally able to present his "discovery" to the posse, who camped overnight in the grove, and returned to town impassioned with news of a mammoth tree nearly 300 feet in height and thirty-two feet across. Newspapers in San Francisco and Sacramento sent reporters to investigate.[8]

For better or worse, the Big Trees of California became an international sensation in the 1850s. The fate of Dowd's tree is illustrative. Dowd's employer, William H. Hanford of the Union Water Company, rode up to see the trees in early 1853, accompanied by local resident William W. Lapham. Lapham immediately acquired the tract, which he named the "Mammoth Grove Ranch," and began construction of a tourist hotel nearby. Recognizing that travel to the spot would remain difficult for some time, Hanford hatched his own plan to create a public for these wonders: he purchased Dowd's Discovery Tree from Lapham, cut it down (figure 2), and removed its bark to a height of fifty feet, which was then reassembled for exhibition in San Francisco. (The solid tree was too massive to haul in it entirety, but promoters made a virtue of their expedient, outfitting the hollow interior with a carpet, piano forte, and seating for forty patrons.) After a profitable engagement in the city, Hanford disassembled the shell and transported it by clipper ship to Manhattan. Negotiations with showman P. T. Barnum to install the tree at New York's Crystal Palace had come to nothing, so Hanford rented a space for himself on Broadway and began posting broadsides for an

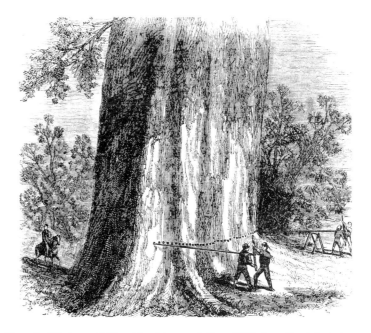

Figure 2 Workmen Felling First Mammoth Tree, 1853, from *Frank Leslie's Illustrated Magazine*, June 9, 1866, p. 188.

independent exhibit. The nefarious Barnum had meanwhile procured his own big tree (albeit a smaller coastal redwood), and preying on the incredulity with which most approached the newspaper descriptions, started a rumor that the Discovery Tree was, alas, a fake and a humbug, sewn together from pieces of several examples by the dishonest Californians. Hanford's venture was ruined, and ended shortly after with his defamed tree consumed in a warehouse fire.[9]

Lapham's scheme proved even more lurid. Lumber from the downed Discovery Tree was used to construct the hotel in the grove. Its epic stump was leveled and made into an attraction, such that in 1858 J. M. Hutchings reported how upon it "on the 4th of July, 32 persons engaged in dancing sets of cotillions at one time"

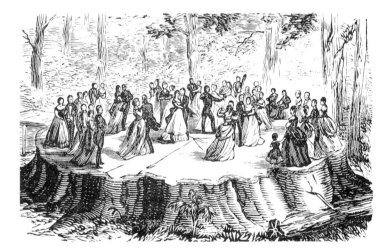

Figure 3 Cotillion Party Dancing on Stump of Original "Big Tree," from Alice Van Schaack, *A Familiar Letter From A Daughter To Her Mother, Describing A Few Days Spent At The Big Trees And The Yo–Semite.* Chicago: Horton & Leonard, Printers, 1871 [unpag.].

(figure 3). Traveling theatrical troupes were contracted to perform on the stump, and, for a brief time, a newspaper called the *Big Tree Bulletin and Murphy's Advertiser* was operating from offices stationed atop it. By this point, two local hotel men from Murphy's had purchased Lapham's property and were busy making improvements. In 1860, what remained of the fallen trunk was converted into a platform for a saloon and two bowling alleys. The leftover timber was fashioned into 5,000 souvenir walking sticks, available for purchase by hotel guests.[10]

The confusion and controversy engendered by the Big Tree sensation of 1854 encouraged even greater acts of vandalism. As additional groves of *Sequoia gigantia* were discovered in the Sierra, the most spectacular specimens got assigned picturesque names: "The Forest King," "The Mark Twain Tree," " "General Sherman," and so on.[11] Two speculators, George L. Trask and George Gale, hit upon the idea of disassembling a prime example called "The Mother of the Forest" for display back east. After purchasing it from Lapham for $1,000, they surrounded their victim with scaffolding to a height of 116 feet, and proceeded to strip off its bark in eight-by-two foot sections (figure 4). Horace Greeley, editor and publisher of the *New York Tribune*, had since taken over management of the failing Crystal Palace from Barnum, and decided that Trask and Gale's "tree mastodon" would be the perfect centerpiece for it. This time around, testimonials were secured from witnesses who had seen the tree in its native habitat—men whose word was beyond reproach— and the 1855 exhibition was a great success. After its New York run, the matriarch's husk was promptly shipped off to Sydenham, England, for an equally triumphant performance in that country's Crystal Palace.[12]

Accounts out of California in this period were replete with descriptions of other oversized wonders: *Hutching's Magazine* published a stream of articles with titles like "A California Grape" or "A

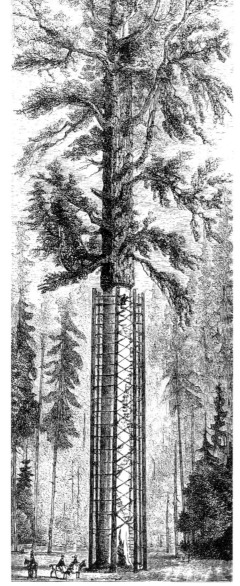

Figure 4 Mother of the Forest
Showing Trask and Gale's
Scaffolding Used to Strip Off
Bark, from *Countries of the World:
Being a Popular Description of the
Various Continents, Islands, Rivers,
and Peoples of the Globe.* London:
Brown, Robert. Cassell, Pettier,
Galpin and Co., [nd].

Large Pear" (two pounds twelve ounces), and much interest was generated by the 2200-pound mammoth cheese.[13] It was, of course, authentic tales of 200-ounce gold nuggets or John Murphy's 1850 arrival in San Francisco with $1.5 million in gold dust (in seventeen sacks, loaded on a six-mule wagon) that excited the most attention. The Big Trees were among those California objects that fired the Victorian imagination; they combined the scientific, the theological, and the useful into one fabulous spectacle of statistics. Botanists counted the rings of the fallen trees and estimated their age on the order of 1,200 to 3,000 years. Having grown accustomed to Europeans looking down their collective noses at a national culture only a few hundred years in existence, Americans could consider this information ultimate vindication. The United States had no Greece, no Rome, no cathedrals or ruins. But it did have Nature, and, as if by the will of God, the Big Trees now turned out to be older than the greatest antiquities of Europe. A pamphlet for the Mother of the Forest exhibit said as much:

> What a stupendous monument raised by the hand of Almighty God is this? The oldest and largest living thing upon the earth; a tree that had beheld the glory and fall of Greece and Rome; the destruction of Jerusalem, of Babylon, and Palmyra; that saw the flight of Paris with Helen; that knew of the wanderings and trials of Ulysses; that had witnessed the incarnation, miraculous mission, crucifixion, and ascension of the Messiah; a tree that had seen the conflicts and success, the defeats and triumphs of Christianity and freedom for ages; that watched the career of that mysterious person, the wandering Jew, for eighteen centuries; that saw the Hegira of Mahomet, the rise and glory of Herculaneum and Pompeii, and their final disappearance in a tomb of fire—could it not tell us of many mighty events now lost to the history of the world which can never be known?

Think of it—this stately monarch of the forest and memorial of the past, fresh and vigorous even now, not a mark of decay upon trunk, limb or leaf, has been reserved until the nineteenth century, and a portion now removed to enable the world to look upon a monument coeval with the Deluge. . . . Its trunk is now blackened from a million fires that have been kindled by the children of two hundred generations, until, finally, modern innovation has dismantled its centurian garb to please the fastidious and curious in the midst of the great mart of commerce and civilization.[14]

The realization that great size meant great age afforded the Victorians a new kind of temporal sublime, the spiritual implications of which were not lost on some period commentators. Thomas Starr King, the famous Unitarian minister, associated the mighty redwoods with the cedars that built Solomon's Temple; Olympus may have had its sacred oaks and laurels, but the evergreen would always remain "the Hebrew tree." "The Mariposa stands [just] as the Creator fashioned it, unprofaned except by fire," Starr King observed, after visiting the sequoia grove there in 1860.[15] He was not alone in recognizing that the California trees might have been contemporaries of Christ. A reporter for the *Boston Daily Advertiser* commented, "what lengths of days are here! His years are the years of the Christian era; perhaps in the hour when the angels saw the Star of Bethlehem standing in the East, this germ broke through the tender sod and came into the air of the Upper World."[16] The trees put human history in perspective. The naturalist John Muir marveled: "As far as man is concerned they are the same yesterday, today, and forever, emblems of permanence."[17] The pantheistic element of American transcendentalism could behold the Big Trees as immortal relics of His handiwork, rooted by providence in native soil.

This was as close as the United States got to making the Old World association of trees and scripture. The sense of an America touched by divinity, with her citizens God's new chosen people and her trees tabernacles of prehistoric date, might well have rendered their wanton abuse a kind of desecration. But the true religion of America was money. Even those imbued with an early spirit of conservation were resigned to this fact, as, for instance, was the writer for *Gleason's*, lamenting Dowd's gutted specimen:

Probably it will not be very long before our readers will be able to get a view of this monster of California's woods for a trifling fee. In Europe such a natural production would have been cherished and protected, if necessary, by law; but in this money-making, go-ahead community, thirty or forty thousand dollars are paid for it and the purchaser chops it down and ships it off for a shilling show. In its natural condition, rearing its majestic head toward heaven, and waving in all its natural vigor, strength and verdure, it was a sight worth a pilgrimage to see; but now alas, it is only a monument to the cupidity of those who have destroyed all there is of interest connected with it.[18]

Muir denounced those who would destroy a great tree in order to demonstrate its grandeur, and wondered if flaying great men and exhibiting their skins might, by the same logic, be the best way of illustrating their greatness. Yet many looked upon the sequoia more as a spectacle of mercantilism. When The Forest King was toppled and brought to Central Park in 1870, broadsides speculated how the trunk "if cut into lumber would make, by calculation, 556,840 feet board measure."[19] A Boston handbill noted how there was enough material in the Discovery Tree "to construct a building entirely of wood as large as Park St. Church."[20] An advertisement for Dowd's relic declared it "the Vegetable Wonder of the World," and translated: "This Tree was entirely sound, and was capable of making the enormous sum of 600,000 feet of lumber. This would have constructed

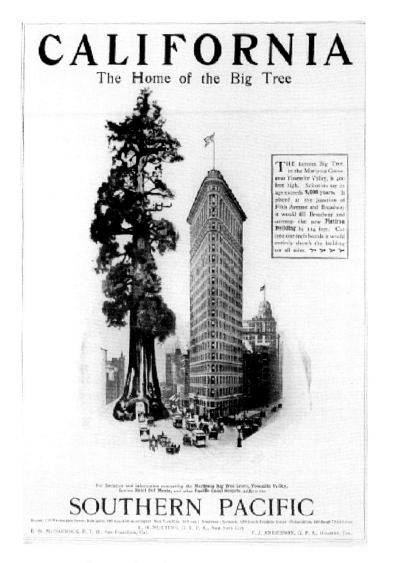

THE famous Big Tree in the Mariposa Grove, near Yosemite Valley, is 400 feet high. Scientists say its age exceeds 5,000 years. If placed at the junction of Fifth Avenue and Broadway, it would fill Broadway and overtop the new Flatiron Building by 114 feet. Cut into one-inch boards it would entirely sheath the building on all sides.

For literature and information concerning the Mariposa Big Tree Grove, Yosemite Valley, famous Hotel Del Monte, and other Pacific Coast resorts, address the

Figure 5 Southern Pacific Railway advertisement, *Country Life in America*, vol. 6 (July 1904) p. 299.

240 houses, each 16 feet wide by 20 feet in depth and suitable height!! . . . It astonishes the beholder, as with mingled feelings of awe and admiration he gazed upon this mighty prodigy of nature, unknown save to the California mountains."[21] As late as 1904, a Southern Pacific Railroad ad would montage a Big Tree alongside New York's Flatiron Building (figure 5), showing the conifer still towering over civilization's latest achievement. "Cut into one-inch boards," the copy read, "[the tree] would entirely sheath the building on all sides."[22] For many entrepreneurial Americans, it was difficult to appreciate a miracle of nature without speculating on how it could be rendered useful or lucrative. Manifest Destiny catalyzed such "mingled feelings," so that to look upon a Big Tree was to see, at one and the same time, a botanical marvel, an expression of God's majesty, and a great deal of timber.[23]

Through a form of synecdoche, the trophy tree stood for the unlimited abundance of all America's forests; the arduous task of cutting one down and transporting it across the country signified our overall mastery of nature.[24] It was not by accident that Albert Bierstadt's wonderfully elegiac painting of the mammoth trees came to hang on the wall of the Massachusetts paper baron Zenas Crane: culture and capital spoke the same language in nineteenth-century America.[25] The photographer Darius Kinsey, working alongside the lumbermen of the Pacific Northwest at the turn of the century, was in a position to make the point more directly. He would frequently illustrate a big fir or cedar, 500 to 600 years old and 50 feet around, with its attackers stationed within and around the enormous undercut they had made (figure 6). That Kinsey's is a spectacle of industrial demolition—one in which the workers and the company took equal pride—is never in doubt. The tree implied the forest, and its size implied profit.

This style of thought underpins our modern appreciation of trees as much as it did that of our forebears. Granted, the environmental

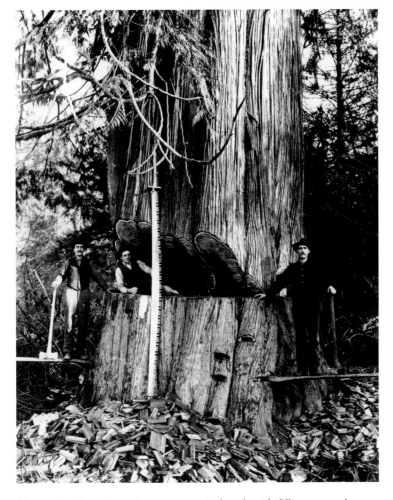

Figure 6 Darius Kinsey. "Loggers on springboards with felling axes and cross-cut saw, Washington, 1906." University of Washington Libraries, Special Collections, UW17617

movement that was spawned by the worst excesses of the nineteenth and early twentieth centuries has led to the protection and improved scientific management of our natural resources. We are far less likely today to cut a hole in a tree so that we may enjoy the experience of driving cars through it. But the anthropomorphism that inspired the Victorians to name their arboreal wonders The Mark Twain or The Forest King and then chop them down is not categorically different from the thinking that, in 1940, could dream up an annual contest in which the heftiest examples of each species vie for the title of National Champ. In retrospect, the notion of trees competing with each other today seems only half serious, but we cannot escape the implications these anthropomorphizing projections mask. For whether a special tree is marked for destruction or for attention, the promotion of the individual over the race ultimately leaves the anonymous majority at risk.

These origins notwithstanding, the Champion Tree program has evolved as our thinking about size has matured. Today, it points to the forest as much as the tree, and to both the political and scientific issues involved in human stewardship of the environment. If one sets industry, theology, and anthropomorphic projections aside, a more purely Darwinian question emerges: Why are not more trees big trees? As the American paleontologist Edward Drinker Cope realized in the nineteenth century, natural selection would seem to hold that, in the struggle for survival, bigger is better. Larger trees, with more extensive root systems and taller or wider crowns, should in principal glean a larger share of natural resources and therefore become more successful at reproducing these traits in subsequent generations. Over vast stretches of time, Cope's rule should favor size, driving species to ever-larger proportions and eventually create a population of giants. And yet, in nature, an abundance of smaller individuals is encountered. Some counterforce evidently exists that opposes Cope's rule, perhaps tied to environmental factors: the

tallest trees are more likely to be hit by lightning, for instance, or outsized canopies become sails in high winds, tending to knock their owners over. In modern times, humans became a determinant: removing the largest and oldest trees for timber gives smaller trees a chance, but reduces the opportunities for the big trees to transmit their genetic codes afield. Under these conditions, reproducing early is more important than monumentality. The oldest known tree is in fact the bristlecone pine, a scrubby, unexploitable survivor found in the remote High Sierra that can live to an age of nearly 5,000 years. Those involved in measuring trees for the Registry today are more compelled by the scientific issues of species growth in relation to ecosystems than in bigness for its own sake.

II.

Barbara Bosworth, a contemporary artist who lives and teaches in Boston, has made an adventure out of finding and photographing the trees on the Register. For her, the listing has functioned like a treasure map, an atlas to promising subjects and a kind of structuring device for the results. With an index to (at last count) 889 champs spread across forty-five states in her hand, Bosworth discovered she held something like one of those ready-made work orders that conceptualists love, akin to that of the Bechers, with their blast furnaces and disappearing coal tipples the world over, or Ed Ruscha and his manifest of every building on the Sunset Strip. Success lay in abundance, in photographing as many examples as possible. Simply getting to the vicinity and working with the local big-tree coordinators, property owners, and enthusiasts to relocate specific titleholders is an odyssey any dedicated outdoorsperson would embrace. Along the way, she has enjoyed the kinship, cooperation, and good company of others who, like her, love and admire the trees and wish to see them preserved.

Figure 7 Barbara Bosworth, *Fireflies in a Jar, 1995*

The triumph of Bosworth's photographs can be seen in how well they navigate the terms of the project that engendered them. Hers is the opposite of the attitude that gave us Hummers, supersized meals, and other holdovers of gigantism in our culture. The photographs in general seem more like deliberations on the ephemeral—on the fragility of life. Images of her elderly mother's hand, fireflies in a jar (figure 7), even the motion of stars overhead at night were made by the photographer during the course of her tree survey. For Bosworth, the trees are not winners because they are big—they are remarkable for having simply stayed alive. "A champion is remarkable for its endurance to survive, to continue to grow to become the largest of its kind," she writes. Of course it is not only growth under

adverse conditions, but alert tree hunters, forces of nature, human activity, and luck that conspire to elect the next winner.

In fact, without their captions and contextual framing, Bosworth's photographic treatments of the trees would not themselves make evident these were the largest examples, so little does size count in the visual strategies she adopts. Her approach more resembles that of the humble Eugène Atget, photographing the trees of St. Cloud outside Paris, than it does that of the heroicizing Bierstadt or the itinerants of the Northwest. In many of her images, the bulk of the tree lies outside the frame. In some, it can even prove difficult to identify which tree exactly is supposed to be the champion. One need only examine Bosworth's circumspect treatment of that prototypical champ, the General Sherman Tree (Giant sequoia, plate 3), to appreciate how ready the artist is to abandon the easy excitement of vertical stature for something more like sculptural beauty.

If the series is not so much about individual achievement, where exactly does it stand in relation to our national tradition? One thing the photographs reveal consistently (and perhaps unwittingly) is the presence of human activity in proximity to her subjects. Where enterprising men in the 1800s brought Big Trees back to civilization, Bosworth's images demonstrate how much civilization—through a kind of reverse osmosis—has now come to our trees. In too many pictures, we see backyards, power lines, cars, houses, pets, hikers, sidewalks, fields, roadways, sheds, fences, and paths—with the promise of future development visible in the background. Of course, we already know that we have been encroaching on our natural habitats for decades. But Bosworth's project, taken as a random survey of tree locations (random because compiled for other reasons), indicates this spread in a visceral way. Our champions are lawn ornaments, park furniture, shade throwers, surrounded by little fences. The Western red cedar still stands in a tract clearcut by loggers (plate 8) only because it appears in the Register. Bosworth

seems to know that, for all their seeming solidity and social status, her trees might be as ephemeral as the California grizzly and the carrier pigeon.

It may be that we anthropomorphize our trees because we are, as a society, ill equipped to deal with abstractions. "Habitat" and "species" are concepts so removed from day-to-day experience that we can only understand them (and take action on their behalf) by way of specific examples: an especially big tree is acknowledged, an especially nice place made into a national park, while the ozone layer (whatever *that* is) gets destroyed by our modern conveniences. The totality of nature—as something that exists independent of our human projections upon it—is unfathomable, and, seen from the limited perspective of human need, useless. Bosworth's photographs seem to echo the feelings of Teddy Roosevelt: "There is nothing more practical in the end than the preservation of beauty, than the preservation of anything that appeals to the higher emotions in mankind." Those higher emotions—implicit in Bosworth's work—know that trees do not need to compete, and that the forest gets along just fine without us. The forest awaits our maturity. The tree points to us.

Notes

1. The first Mr. America was actually Bert Goodrich, who won the title in 1939, in a competition that included both amateurs and professionals vying in three categories. (Goodrich participated as a professional.) A second contest the same year elected Roland Essmaker the winner; this competition was open to amateurs only and included a weightlifting component. The 1940 contest was held to coincide with the New York World's Fair, and officially adopted "Mr. America" as its title. The event was oriented to physique and posing, and included separate competitions for body parts, such arms, legs, and abdominals.

2. The Mr. America competition was organized by a promoter named Johnny Hordines and held at Gardner's Reducing Salon and Gymnasium in Amsterdam, New York. The American Forestry Association was founded in

1875, with the goal of protecting forests from wasteful logging practices. Now a nonprofit agency based in Washington, D.C., the AFA changed its name to American Forests in 1992. The group works with corporate partners such as Exxon, Chevrolet, and the Bruce Hardwood Flooring Company to sustain its advocacy and reforestation efforts.

3. The swimsuit event was introduced in 1921 as the "Inter-City Beauty Pageant." It was the centerpiece of Atlantic City's new "Fall Frolic," a weekend of festivities intended to prolong the resort's tourist season beyond Labor Day. Sixteen-year-old Margaret Gorman of Washington, D.C., was the first winner; Gorman stood five feet one, weighed 108 pounds, and measured 30-25-32. Over the decade, the pageant grew in popularity, but a backlash from women's and religious groups, coupled with financial problems, closed down the spectacle from 1929 to 1932. It was then revived, with fifteen-year-old Marian Bergeron being crowned Miss America 1933, and reinvented, with a talent segment, chaperone matrons, and the system of state representation being added in 1938. However, a contest rule in this period mandated that participants be Caucasian. The name of the event was officially changed to the Miss America Pageant when it moved to Convention Hall in 1940. The scholarship program was instituted in 1944.

4. Simon Schama, *Landscape and Memory* (London: HarperCollins, 1995) 214–215, 593nn 50, 51.

5. P. L. Travers. "In Search of the World Tree," *Parabola* 24, no. 3 (August 1999). In the first-century Gospel of Nicodemus, Christ passes into hell to release the dead and, taking Adam's hand, says "Come with me all you who have suffered death through the tree which this man touched. For, behold, I raise you all up again through the tree of the cross." See Schama, *Landscape and Memory,* 219.

6. Schama, *Landscape and Memory,* 214.

7. Schama, *Landscape and Memory,* 216.

8. Joseph H. Engbeck, Jr., *The Enduring Giants: The Giant Sequoias, Their Place in Evolution and in The Sierra Nevada Forest Community* (Berkeley, California: University of California, Berkeley Extension, 1976), 74. The Calaveras Grove was certainly known to the Washo and Miwok tribes who hunted in the area, so the "discovery" of the trees is simply a euphemism for the public announcement of their existence. In fact, other white men "discovered" big trees prior to Dowd. A member of Captain Bonneville's

fur trapping expedition of 1833, Zenas Leonard recorded in his journal of having found "some trees of the Redwood species, incredibly large—some of which would measure sixteen to eighteen fathoms around the trunk," but the journal remained an obscure document. The first sheriff of Mariposa County, James Burney, came across a grove of sequoias in October of 1849, but when his story of them was characterized by the townspeople of Mariposa as a "big yarn," he swore to never speak of them again, lest his authority be compromised. (69–73).

9. The story of the Discovery Tree's exhibition is recounted in Dennis G. Kruska,: *History of the Exhibitions, 1850–1903* (Los Angeles: Dawson's Book Shop, 1985), 18–31.

10. Kruska, *Sierra Nevada Big Trees,* 32; Engbeck, *Enduring Giants,* 80–93.

11. Others included The Old Bachelor, The Tree Sisters, Husband and Wife, and Mother and Son, The Three Graces, The Orphans, The George Washington Tree, The Abraham Lincoln Tree, The Florence Nightingale Tree, The General Noble Tree, and The Captain Jack Tree. On this, see Engbeck, *Enduring Giants,* 83, and Claire Perry, *Pacific Arcadia: Images of California 1600–1915* (New York: Oxford University Press, 1999), 120.

12. Kruska, *Sierra Nevada Big Trees,* 33–38; Engbert, *Enduring Giants,* 77–78.

13. "A California Grape," *Hutching's Illustrated California Magazine* 2, no. 6. (December 1857):. 203; "A Large Pear," *Hutching's Illustrated California Magazine* 1, no. 5 (November 1856): 203. The mammoth cheese was manufactured at San Francisco's What Cheer House and put on display at one of the early Mechanics' Institute exhibitions.

14. Exhibition pamphlet, "Mammoth Tree of California," in Peter Johnstone, ed. *Giants in the Earth: The California Redwoods* (Berkeley, California: Heyday Books, 2001), 86–87.

15. Thomas Starr King, *A Vacation among the Sierras,* as quoted in Schama, *Landscape and Memory,* 189.

16. *Boston Daily Advertiser,* Nov. 3, 1869, as quoted in Schama, *Landscape and Memory,* 190.

17. John Muir, "Hunting Big Redwoods," in Johnstone, ed., *Giants in the Earth,* 89.

18. *Gleason's Pictorial Drawing-Room Companion* for October, 1853, as quoted in Engbeck, *Enduring Giants,* 77. Others protested the destruction of the trees: Starr King wondered if the sacrifice might be worthwhile, given the honor it brought his state: "In our estimation, [felling the Dowd Discovery

Tree] was a sacrilegious act; although it is possible, that the exhibition of the bark, among the unbelievers of the eastern part of our continent, and of Europe, may have convinced all the 'Thomases' living, that we have great facts in California, that must be believed sooner or later. This is the only palliating consideration with us in this act of desecration." James Mason Hutchings, *Scenes of Wonder and Curiosity in California* (San Francisco: Hutchings & Rosenfield, c.1860), 44. Botanist Berthold Seemann seemed to agree with this rationalization: "If this exhibition on one hand fills us with regret at the vandalism of mercenary men, it on the other brings home to us the prodigious power of American vegetation." Engbeck, *Enduring Giants,* 77

19. Kruska, *Sierra Nevada Big Trees,* 40.

20. Reproduced in Kruska, *Sierra Nevada Big Trees,* 44.

21. Advertisement in the *San Francisco Sun*, October 5, 1853, reproduced in Kruska, *Sierra Nevada Big Trees,* 21

22. Perry, *Pacific Arcadia,* 119–121.

23. On this, see Douglas R. Nickel, "Art, Ideology, and the American West," in William Deverell, ed., *A Companion to the American West* (Oxford: Basil Blackwell, 2004), 361–374. One need only recall the tall tale of Paul Bunyan, the legendary timberman of the North Woods, to recognize the American ethos at work: the invention of an oversized individual to match our oversized forests.

24. The vast forests of the Northwest engendered their own reactions of sub-limity. Samuel Wilkeson, a business agent for the Northern Pacific Railroad, was sent to check the rail route from Minnesota to the Washington Territory in summer of 1869. "Oh! What timber," he declared in his report. "These trees—these forests of trees—so enchain the sense of the grand and so enchant the sense of the beautiful that I linger on the themes and am loth to depart. Forests in which you cannot ride a horse—in which you cannot possibly recover game you have shot without the help of a good retriever—forests in which you cannot see, and which are almost dark under a bright midday sun—such forests, containing firs, cedars, pine, spruce and hemlock, envelop Puget Sound and cover a large part of Washington Territory, surpassing the woods of all the rest of the globe in the size, quantity and quality of the timber." Quoted in Richard L. Williams and the editors of Time/Life Books, *The Loggers* (New York: Time-Life Books, 1976), 119.

25. Schama, *Landscape and Memory,* 207.

Acknowledgments

Making a book is never an individual endeavor. So many people have given of themselves to enable these pictures and this book to happen. Roger Conover, the book's editor, has been a joy to work with. He trusted this work the first time he saw it and has made transforming it into a book a smooth and pleasant process. Yasuyo Iguchi, Terry Lamoureux, Sandra Minkkinen, and Lisa Reeve of The MIT Press also helped to shape this book.

Thanks to Mark Schwartz and Bettina Katz, enthusiastic lovers of photography; The Davey Tree Expert Company, sponsor of the Big Tree Program; and The Center for Creative Photography at the University of Arizona in Tucson, Arizona. Their generosity helped to make the publication of this book possible.

I am especially indebted to the writers John Stilgoe and Doug Nickel for their valuable contribution to this work. Bill Ginn loved the idea of this book from the beginning. Toby Jurovics was an instrumental, early supporter of this work. Rebecca Solnit's encouragement was crucial. Thanks to everyone at Color Services in Needham, Massachusetts.

While the locations of these champion trees are known and listed by American Forests in Washington, D.C., actually finding the trees required the help of many people. At the national level, Deborah Gangloff, director, and the staff at American Forests got me started. Within each state, designated tree coordinators gave me more specific information. Once I was in the neighborhood of one of the trees, local tree enthusiasts went out of their way to give me detailed maps and directions. I will not soon forget the kindness of the people who personally led me to the trees. Finally, all the tree owners, proud of their champions, made it possible for me to make the photographs. The list of people who helped me is lengthy. I wish to thank them all.

By their presence in my life, many friends became part of this project. D'Anne Bodman's life and poetry brings beauty into my world and confirms it really is okay to live passionately. Her husband, Harvey Nosowitz shared his culinary creations many times. Joann Brennan and Andrea Zocchi openly provided me a western home away from home. Kim Zorn Caputo showed me how to live life with grace and strength. Jacquie and Jim Dow filled many of my evenings with grand friends and conversations around their dinner table. Lisa Feck and Chris Hammel reentered my life with food and physics. Joanne Lukitsh offered endless encouragement and long walks through our neighborhood. Eric Paddock shared so many conversations about life and photography. I learn something new every time we talk. Annie Rearick relentlessly believed in my pictures. Rosemary Rovick gave me straightforward, no-nonsense advice on all matters. Sage Sohier, my hiking and printing companion, and David Feingold helped me think clearly and see priorities. My gratitude goes to Cheryle St. Onge for her undying friendship. I thank Steve Tourlentes for just plain always being there and Ted Tourlentes for opening my eyes and showing the world in detail. I am grateful to my colleagues at Massachusetts College of Art—Virginia Beahan, Alane Brodrick, Amber Davis, Tom Gearty, Frank Gohlke, Jeff Keough, Laura McPhee, Abe Morell, Nick Nixon, Galen Palmer, Sam Schlosberg, Shellburne Thurber, Lisa Tung—for always talking about pictures.

My sister, Joan Frato, and my brother-in-law, Kenneth Frato, made me welcome in their home for many extended stays during my photographic travels. My niece, Katherine, and nephew, Jeffrey, accompanied me on several tree trips, making those my most memorable.

The inspiration for these photographs began with my father who simply loved trees and passed that on to me. This book was also made possible by my mother, Ethel Bosworth, and brother, Ronald Bosworth, because family is always there.

Marc Elliott, thank you.

Former Champion American Elm, Kansas, 2001

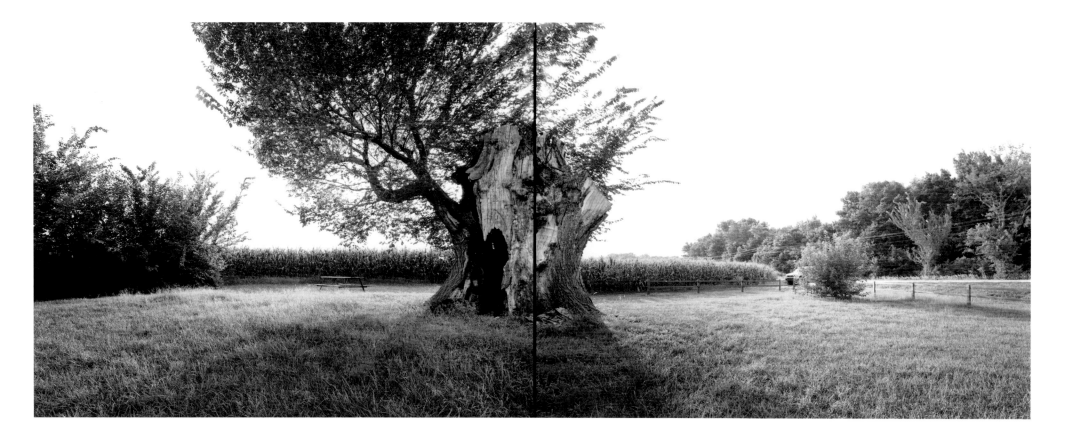

Acquired by Roger Conover

Production coordinated by Terry Lamoureux

Text edited by Sandra Minkkinen

Designed by Yasuyo Iguchi

Composition in Bembo and Akzidenz Grotesk by the MIT Press

Printed on Gleneagle Dull by Meridian Printing, East Greenwich, Rhode Island

Bound by Acme Bookbinding Co., Inc., Charlestown, Massachusetts